A–Z
OF
CARDIFF

PLACES - PEOPLE - HISTORY

Dic Mortimer

AMBERLEY

Many thanks to Cardiff Central Library,
and to all previous publications about Cardiff.
Pictures are copyrighted to those credited.
For much more on Cardiff see dicmortimer.com.

Dedicated to Clifford Munn

First published 2016

Amberley Publishing
The Hill, Stroud, Gloucestershire, GL5 4EP
www.amberley-books.com

Copyright © Dic Mortimer, 2016

The right of Dic Mortimer to be identified as
the Author of this work has been asserted in
accordance with the Copyrights, Designs and
Patents Act 1988.

ISBN 978 1 4456 5660 1 (print)
ISBN 978 1 4456 5661 8 (ebook)

British Library Cataloguing in Publication Data.
A catalogue record for this book is available
from the British Library.

Typesetting by Amberley Publishing.
Printed in Great Britain.

Contents

Introduction

From its birth as a settlement at the lowest crossing point of the River Taff, via periods as a Roman garrison, Anglo-Norman fortress, feudal lordship, booming coal port and post-industrial invalid, through to today's capital of a fledgling Welsh democracy, Cardiff has accrued a vast amount of fascinating social and cultural history.

A-Z of Cardiff examines the city from a variety of angles: architecture, environment, streetscape, national institutions, famous and infamous people, heroes and villains, natural and unnatural features, art and music, language and dialect, traumas and tragedies, and the surprising, the neglected and the quirky.

This book takes the reader on a tour of the Welsh capital's past and present in alphabetical order. Here are the stories behind its most notable streets and buildings, its distinctive features and its sons and daughters, all brought together in an attempt to get under the skin of this dirty old town beside the Severn Sea.

A

Adam Kyngot

In the beginning there was Adam ... but, since the Genesis story of the Abrahamic religions is incompatible with all known science and comprehensively disproved by evolutionary genetics, it perhaps shouldn't be taken literally. However, there is a place where an Adam really was at the beginning: Cardiff, Wales.

Adam Kyngot (1310–75) is the oldest actual person namechecked by an extant Cardiff city centre street. Some streets take the names of various relatives and in-laws of the absentee aristocrats who owned Cardiff (Charles, David, Edward, Fitzalan, Frederick, Howard, Mary Ann, Millicent), some refer to the great landowning estates themselves (Bute, Tredegar), some bow to royalty (Caroline, Edward VII), some scrape to the influential (Callaghan, Churchill, Wesley), some commemorate minor Victorian officials, worthies and businessmen (Havelock, Hill, Knox, Sandon, Saunders, Scott, Wood), but it is Adam Kyngot, more by accident than design, whose name has endured the longest.

And, unlike nearly all the others above (bar Wood), Adam was a Cardiffian. In fact his surname is an English transliteration of what today is a Cardiff suburb: Cyncoed. He was the porter of Cardiff Castle, a job that came with the tenancy of a farm that grew food for the castle on the fertile moors to the east of the walled garrison – making him the archetypal underling of the age-old 'the rich man in his castle, the poor man at his gate' relationship. The fourteenth century was a traumatic one for Cardiff. The castle was in the clutches of the murderous Despenser family; lethal plague epidemics and famines repeatedly ripped through the population; the Welsh wars of independence were at their peak, regularly spilling over into Cardiff from the primary battlegrounds in the hills; there was barely even a subsistence economy generated by the depressed wool trade through the minor harbour; and the impoverished hamlet on the Taff actually depopulated throughout the period. In this context, with Cardiffness a work in progress and yet to be forged into an identity, Adam Kyngot can be seen as a proto-Cardiffian, helping weave the threads of divided loyalty, contradictory impulse, scrabbling social climbing, mercenary self-interest and sheer survival instinct that are significant hues in the Cardiff tapestry to this day.

As a porter, Kyngot was effectively front-of-house at the Welsh outpost of the despotic Despenser dynasty, which is hardly a character reference. Notorious for extraordinary violence even by the standards of the time, many of the Despensers came to gruesome ends themselves at the hands of their fellow Anglo-Normans in a sequence of power struggles in England. By the time the Third Marquess of Bute (1847–1900) undertook his extravagant reimagining of Cardiff Castle in the nineteenth century, the Despensers' reputation as the epitome of wicked unscrupulousness was so well that established their heraldic image in the banqueting hall was deliberately hung upside down as a sign of disgrace – the solitary coat of arms of all the usurper lords of Glamorgan to receive such disrespectful treatment.

So, even though next to nothing is known about Adam Kyngot, it seems reasonable to assume he was no angel. It could be said he didn't give a damn. Barely a footnote in Cardiff's history, he would have joined the numberless ranks of the totally forgotten had it not been for his occupancy of the farm. After he died, the farm, along with its extensive corn fields and pastures, gradually became known as Adamsdown as the anglicisation of the area proceeded remorselessly. It remained in the possession of the lords of the castle, passing from one compliant tenant farmer to the next, right through to the Industrial Revolution and coming of the Bute dynasty, who soon bought up most of the surrounding farmlands too. Then the construction of the first dock (Bute West, 1839) and the first railway (Taff Vale, 1841) triggered Cardiff's rapid expansion on the back of valleys' coal. The terraced streets of Newtown, Cardiff's first leap beyond the town walls, began to eat eastward into the Adamsdown countryside along an old track called Whitmore Lane, and after widening and improvements in 1853 the council renamed the lane east of the Taff Vale Railway's bridge Adam Street, a bustling road of pubs, shops and small industries running through the tightly packed terraced streets of Newtown and loomed over by the 1832 county gaol.

Adam was immortalised, and his position was later further entrenched with the creation of the Adamsdown ward in a 1967 council reorganisation out of an area previously dispersed between Newtown, Roath and Splott wards. By then Adamsdown was a far cry from Kyngot's meadows, woods and hedgerows: it didn't have a single public green space and the old farmhouse itself was long gone, pulled down in 1874 and replaced by the Adamsdown Gospel Hall on Kames Place.

With a district, a street and now an electoral ward named after him, Adam Kyngot had become an even more unique Cardiffian. Nobody, least of all Adam himself, could have possibly imagined such a prospect 700 years ago; proof that nothing is preordained, events do not proceed rationally and only the unpredictable is predictable.

Today Cardiff's smallest, most densely populated ward is poor and suprisingly lacking in amenities considering how close it is to the city centre. Few of the 10,000 population ever actually call it Adamsdown – most would just say they live in Cardiff – and the name is falling out of vernacular speech. The Assembly's forthcoming reorganisation of Welsh local government, in which the number of councils will be cut from twenty-two to less than ten, will trigger a drastic reduction in the number

Adam Street.
(Dic Mortimer)

of wards across Wales – and those as geographically tiny as Adamsdown will be the likeliest candidates for the chop. Adamsdown is beginning to feel in peril.

But Adam Street will surely survive. It's a vehicle-clogged dual carriageway and major radial artery, one of only two east–west routes into Cardiff city centre, as well as the main access point to Cardiff Bay via the 1989 Central Link flyover. Surrendered to the car, the hostile environment is unconducive to any kind of street life and features a range of structures that encapsulate Cardiff's recent trajectory. The south side is given over to ranks of privately run student apartment blocks: the 1992 Territorial Army Centre, Tŷ Llewellyn; the 2012 Cardiff Central Fire Station; the vast self-storage facility; and a large open-air car park earmarked for 'a mixed development of apartments, shops, restaurants, a 200-bed hotel and offices'.

On the north side is the 'Faculty of Creative Industries' of the University of South Wales (formerly the University of Glamorgan), which goes by the title ATRiuM. The 2007 transformation of the telephone exchange was extended into an adjacent sliver of rare greenery in 2015 to sate the growth fixation of Wales' second biggest university. This completed a process started in Kyngot's era: the eradication of all traces of vegetation from Adam Street.

Shirley Bassey

Who is the most famous Cardiffian of all time? There can be no argument: the answer is Shirley Bassey, the girl from Tiger Bay whose career is of staggering longevity. Shirley has been singing in public since 1949 when, as a twelve-year-old, she got up on a table and performed for a few shillings at the Casablanca club in Bute Street. Nearly seventy years later, approaching the age of eighty, there is no hint that she would even contemplate retiring, no sense that her timeless appeal could ever become out of date, and no diminishment in the appetite of her worldwide legion of fans for more, much more. No other singer from the 1950s has outlasted her, and thus there is no other who has encompassed the multiple mutations of the entertainment industry from the last days of music hall via vaudeville, tin-pan alley, pop charts, adult-orientated albums, movie soundtracks, TV light entertainment and cabaret through to today's open-air festivals and digital platforms. Somehow she has captured the atmosphere and zeitgeist of every decade of her life without chasing 'here today, gone tomorrow' trends and fashions, wallowing in nostalgia or attempting to be anything other than true to herself. More than any entertainer alive, she is the ultimate survivor and the very definition of a 'star'.

Normally, even for the biggest names in show business, death is the precondition for legendary status; few can justifiably claim to be legends in their own lifetime. Shirley Bassey is one of those precious few, defying circumstances of extreme disadvantage to triumph against all the odds on her own terms. She was the seventh Cardiff-born child of an impoverished single mother from Middlesbrough who had moved to Tiger Bay to escape censorious disapproval of a cross-racial pregnancy. Born in 1937, young Shirley had a chaotic upbringing, living firstly at No. 182 Bute Street in rooms above the Canadian Café, one of countless music-filled drinking-den nightspots catering to shore-leave mariners on the long, straight thoroughfare down to the docks, before moving, at age two, to No. 132 Portmanmoor Road, a mile away in the equally poor Splott, after her biological father was jailed for serious sex offences (he was deported to Nigeria in 1943, meaning Shirley never actually met him). Shy but attention-seeking, unknowing but highly self-aware, a dreamer but completely unambitious, a loner but socially adept, a scruffy tomboy but effortlessly attractive, she was a unique,

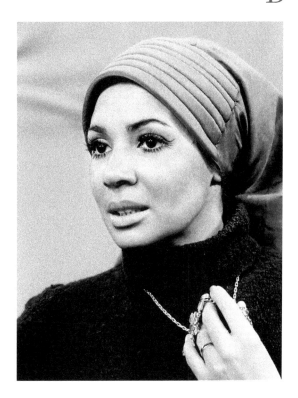

Shirley Bassey, 1971.
(Dutch National Archives)

contradictory collection of characteristics that combined to forge rare talent. Since all the performing arts have now been commandeered by the privately educated upper-middle classes and it is virtually impossible for working-class people to break into what are oxymoronically termed the 'creative industries', it is safe to say that we will never see someone rise to such heights from such humble origins again. Because she's irreplaceable, we will miss her so badly when she's gone, rather like both her Cardiff addresses – old Bute Street was demolished along with all of Tiger Bay in the 1960s and was replaced by the Butetown Estate, while Portmanmoor Road suffered the same fate when Lower Splott was flattened in the 1970s (it is now a trading estate).

It is odd how the very qualities which at times made Bassey seem uncool after her initial burst of success in the late 1950s and early 1960s, now make her seem refreshing and relevant. Her lack of self-consciousness, epitomised by ill-advised tours of apartheid South Africa in the 1970s, speaks more of her upbringing by a white mother in the easy-going, multiracial Cardiff docks than anything else. Her melodramatic performances, once written off as arch and kitsch, now seem like dazzling gifts of energy and commitment to her audience. Her unapologetic enjoyment of the shiny fripperies of riches and fame, no surprise for a girl who had to pinch another child's jam sandwich at Moorland Road Primary School or go hungry, was long condemned as shallow and vulgar, yet now appears classy, glamorous and unhypocritical when set against contemporary 'celebrity'. Her repertoire, formerly denounced as dated-showbiz, is these days appreciated as a daringly eclectic garnering of global

influences, a pioneering fusion of everything from calypso to torch songs, European operetta to American razzamatazz. Her flamboyant, regal manner, dismissed as drag-queen camp, is now recognised as a highly attuned, self-mocking irony decades ahead of its time.

There was no luck involved; it was sheer merit and determination that earned Shirley Bassey her place at the top table, reserved for the world's supreme entertainers. That voice, with its unmistakeable, ungentrified Cardiff vowels, has an instantly recognisable quality most singers would die for. The back catalogue of songs, from genre-defining Bond theme songs 'Goldfinger', 'Diamonds Are Forever' and 'Moonraker', through to confessional show-stoppers like 'I (Who Have Nothing)', 'Big Spender' and 'This is My Life', place her up there with her girlhood heroes Judy Garland (1922–69) and Edith Piaf (1915–63), and even in her eighth decade she has added to the pedigree with self-referencing anthems 'The Performance Of My Life' and 'The Girl From Tiger Bay', as she finds a deeper timbre and philosophic tone in her later work. But more than all of this, her trump card is her own personality, forged in the university of life on the backstreets of Splott: uncalculating yet clever, down to earth yet a diva, tough yet big-hearted, worldly wise yet romantic. After desperate poverty, teenage pregnancy, two divorces and a daughter's suicide, she has lived the life, not just sung about it.

She got out of Cardiff as soon as she could, but Cardiff never stopped loving her and she has always come back. And when she topped the bill at the concert to celebrate the opening of the Welsh Assembly in 1999, stunning in an off-the-shoulder gown bedecked in the Welsh dragon, belting it out over the transformed docks where she grew up, she somehow completed a circle began long ago, and transcendentally rose into the pantheon of all-time Welsh greats.

C

Cefn Garw Quarry

On the southern side of Heol-y-Fforest above Castell Coch, this huge, boulder-strewn, shelved cavity is in the early phases of plant colonisation, having not been worked since 1987. Water has accumulated over the years in the quarry bottom to form a dark, scary lake. Dramatic faults, folds and thrust planes on the north face, exposed by nineteenth-century quarrying into the massive beds of dolomite, reveal the geological transition between limestone and sandstone.

Churches

The sites with the longest unchanged use in Cardiff are those of the parish churches established by the Norman conquerors from the twelfth century onwards. Following the toppling of Celtic Christianity, imposition of Roman Catholicism and creation of dioceses and parishes on the English model, they were usually built on ground previously occupied by Welsh 'llanau'. Most of these medieval churches have undergone major changes since then, either because of the upheavals following the sixteenth-century Protestant Reformation or because of the massive rebuilding programme by the Anglican Church in response to the rise of Nonconformism in the nineteenth century. Three have disappeared entirely – coincidentally, all dedicated to Mary. St Mary's Caerau was levelled to the ground by gratuitous vandalism; St Mary's Whitchurch was demolished and relocated; and St Mary's in St Mary Street, Cardiff's first parish church, was destroyed by flood damage in the seventeenth century. As a result its subsidiary chapel, St John's, the oldest building left in the city centre today apart from the castle, became the town's main church by default. St John's is a well-documented, high-profile church, as is the cathedral at Llandaf, but the other surviving medieval churches scattered around today's suburbs of Cardiff are less well known:

Capel Llanilltern

St Ellteyrn's was founded as a wayside holy place on the Roman road to Llantrisant by sixth-century Celtic monk, Ellteyrn. The thirteenth-century Norman replacement,

a chapel of ease of St Fagans, was given a powerfully simple restoration in 1863. Today it's used only for the occasional choral evensong. Within are a fine thirteenth-century font and a rare sixth-century gravestone with a perplexing Latin inscription (*VENDVMAGL HIC IACIT*) the cream of Academia has failed to decode.

Lisvane

St Denys' is a simple fourteenth-century church on a much older Celtic site (*see* Llansien), noteworthy for its impressive tower with no buttresses, slightly tapered all the way up to a saddleback roof. Reformation purging and an 1878 restoration haven't marred the church's evocative medieval core.

Llanedeyrn

Whitewashed St Edeyrn's, with its intriguing hotchpotch of multi-period windows, stands bereft on an abandoned stump of back-lane severed by the scissors of Eastern Avenue and the A4232. Dedicated to local monk Edeyrn, who helped spread Christianity across Wales in the sixth century, the twelfth-century church took over a llan of great antiquity. An enormous yew tree by the porch, 40 feet (12 metres) in girth, is 2,500 years old, indicating a pre-Christian pagan site. The yew would already have been 1,000 years old when Edeyrn was buried here in AD 522.

Llanisien

Another missionary monk sent out from the mother church at Llandaf in the sixth century was Isan, who also used the Latin name Dionysius, easily corrupted to Dennis/Denys. His original llan was close to a spring on a pre-Christian site (today's Llandennis Oval) with an outlying chapel, dedicated to his Latin identity Denys, a mile north at Lisvane. St Isan's was begun in the twelfth century and, despite enlargements on its north side in 1872 and 1908, retains many original features, including its battlemented tower, porch with incredibly small inner door and Gothic east window.

Michealston-Super-Ely

Built in the thirteenth century on a knoll by the banks of the River Ely where a Welsh 'llys' (court) had been located, St Michael's, hidden away at the end of Persondy Lane, was given a drastic makeover in 1863. Medieval elements were swamped by a much-criticised fiddly restoration which resulted in an impractically small side chapel, a blocked arch and a marooned tower doorway. The unusual building, which held its last service in 2010, creaks with powerful ambience, forlorn and reproachful in a shady dell.

Pentyrch

St Catwg's is dedicated to Cadog, one of the great scholars of early Welsh Christianity. The 1857 church by John Prichard (1817–86) entirely eradicated the thirteenth-century Norman church which had been erected on the site of a Welsh holy well, but artefacts from the medieval church were rescued and can be seen inside. Outside

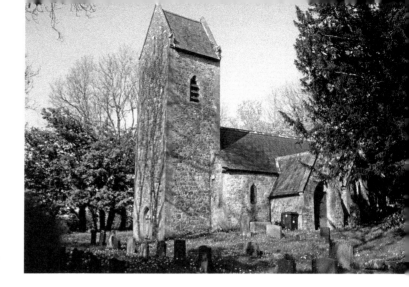

St Michael's,
Michaelston-super-Ely.
(John Lord)

it is a typically exhilarating Prichard tour de force of steeply pitched roofs, flying buttresses and a daring tower crowned by a spire straining for the heavens.

Radyr

There are some scant thirteenth- and fourteenth-century remnants at St John's, which was rebuilt in the 1850s and then superseded as Radyr's main parish church in 1904 by Christ Church in Heol Isaf as Radyr migrated northwards. St John's pre-Christian site gave Radyr its name (from the old Welsh *Rhadur*, blessed place) but it is now actually in the middle of Danescourt. Oozing antiquity, the churchyard boasts a quirky lychgate and a yew tree that predates the first church.

Roath

St Margaret's on Waterloo Road is one of the finest works of John Prichard, undertaken just after he completed his masterpiece at Llandaf Cathedral. He was commissioned by the Butes to produce something a lot grander than the simple, limewashed Norman church with a bell turret where the 1st Marquess (1744–1814) had established the family mausoleum. It was pulled down, and by 1873 Prichard delivered a glorious essay in Celtic exuberance. The squat, cruciform building with walls of split Pennant sandstone and a huge east window gives no hint of its sensational interior: a dazzling display of virtuoso polychromy, unmatched in Wales, with stone, marble and alabaster in black, red, cream, pink, grey and green, forming walls, arches and columns into a rhapsody of colour patterns. Even more astonishing is the Bute mausoleum, rebuilt as a chapel where the nine coffins from the original vault are contained in six massive, sombre sarcophagi (plus a smaller seventh) of polished red granite that have no parallel in the UK – mind-blowing evidence of the Bute's unimaginable wealth and overweening self-importance. In the churchyard are the last vestiges of the medieval church: a couple of carved stones, once part of an arch, now placed on each pillar of the south gate to the churchyard. Here also is another venerable yew which, from its 6-metre (20 feet) girth, could be as much as 1,200 years old, a legacy of the sacred Druid grove which was once here, still breathing in the machine age.

Rumney

St Augustine's was constructed in 1108 on a time-worn Celtic mound and dedicated to the Benedictine monk who had been Anglo-Saxon England's first Archbishop of Canterbury in AD 597. It stands in an atmospheric churchyard, a peaceful green oasis less than 100 metres from noisy Newport Road. The earliest surviving feature is the thirteenth-century arched west doorway in the battlemented tower, while most of the remainder is from the fifteenth century.

St Fagans

Twelfth-century St Mary's on Crofft-y-Genau is considered one of Glamorgan's finest churches for the decorative brio of its fourteenth-century nave and chancel. The stonework is a feast of idiosyncratic touches among the arches and shafts. Local landlords the Earls of Plymouth funded an enlargement and revamp in 1860 which included much dazzling stained glass. The Church in Wales, disestablished and independent since 1920, should surely have dropped the Norman dedication to Mary and reinstated the previous Welsh dedication to third-century missionary Ffagan, if only to iron out the nonsensical discrepancy of a place named specifically after its church having a church with an entirely different name.

St Mellons

Visible for miles on its pine-covered hillock, this church was built in 1360 on a pre-existing llan. Many modifications over the centuries have produced a shambolic raft of arches, pillars and windows, and there are eccentric features like a large 'squint' and an exquisite foliage image niche in the east wall. Outside is a stone stump of an ancient Celtic cross and a carved, bilingually inscribed lychgate at the bottom of Church Lane. The precise origin of the saint's name has never been satisfactorily resolved – is it Mellonius, the fourth-century Bishop of Rouen, or Melanius, the sixth-century Bishop of Rennes?

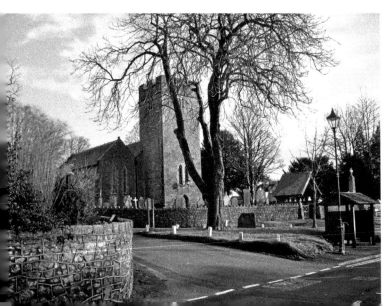

St Mary's, St Fagans.
(Peter Broster)

D

Roald Dahl

Llandaf-born Roald Dahl (1916–90) was a complex man. In person he could be snobbish, greedy, arrogant, untrustworthy and malicious. But, writing in his beloved garden shed in Great Missenden, where he lived most of his life, he was able to draw on that darkness and harness those demons to produce a series of compelling books for children, many of which were made into successful films. Like no author before him, Dahl tapped directly into a child's delight in the gruesome, anarchic, mischievous, macabre, hilarious and the (preferably sadistic) comeuppance of adults. If anybody provides clinching proof that 'niceness' isn't a precondition for creative genius, it is Roald Dahl.

Dahl's dysfunctional personality was forged by his unorthodox childhood. His parents were social-climbing Norwegians who had come to Cardiff in 1885 to get a slice of the boom town's easy money. Father Harald Dahl (1863–1920), who had lost his first wife in childbirth and an arm as a result of botched surgery, soon made a fortune as a shipbroker from offices in Dock Chambers on Bute Street (today's Butetown History & Arts Centre). This allowed him to commission Villa Marie in Fairwater Road in 1907 as a purpose-built family residence (now called Tŷ Gwyn, it recently sold for £1.5 million). In 1918 the Dahls moved to huge Tŷ Mynydd in nearby Radyr (demolished in the 1960s, but the lodge survives on Heol Isaf). It was there that Roald was born, the fourth of five children.

His Lutheran parents had him baptised in the corrugated-iron 1869 Norwegian church that stood between the Bute West and Bute East Docks (the church closed in 1971, was dismantled in 1987 and then rebuilt in wood alongside the Inner Harbour in 1992. It is now an arts centre, and the Wales Millennium Centre now occupies its previous position; the Bute West Dock's surviving Oval Basin was renamed Roald Dahl Plass in 2002). When he was four, double tragedy struck: one of his sisters died of a burst appendix aged only seven and a few weeks later his father, overwhelmed with grief, died of pneumonia. Mother Sofie Dahl (1885–1967) was forced to downsize and the family moved to the smaller Cumberland Lodge back in Llandaf (now part of Howell's School on Cardiff Road). In the light of these traumatic events, it is possible to see how the seeds of the adult Dahl's cruelty, cantankerousness, hypochondria and callous disregard for others were sown.

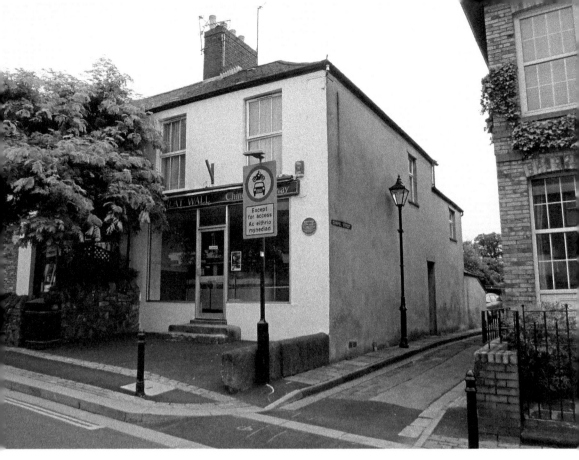

Made famous in Roald Dahl's autobiography *Boy*, Mrs Pratchett's sweetshop in Llandaf High Street as it is today. (Jvhertum)

After two years at the Cathedral School in Llandaf, he was packed off to boarding school at Weston-super-Mare in 1925 before going to Repton School in Derbyshire in 1929. He had departed from Cardiff for good and, other than a few crystallised childhood memories he wrote about in his 1984 autobiography *Boy*, Cardiff seems never to have figured in his consciousness again (there is a blue plaque on the former sweetshop in Llandaf High Street where the naughty Dahl and his pals put a mouse in Mrs Pratchett's gobstopper jar). Restless and hyperactive, his adventures were just beginning.

He hated the private school Repton and left in 1934. He had periods working his passage on merchant ships, hiking through Newfoundland and as a Shell oil representative in east Africa, and then joined the RAF at the outbreak of the Second World War. Having survived a fractured skull in a 1940 crash in the Egyptian desert, he was an ace fighter pilot flying Hurricanes in aerial combat over Greece and Egypt before crippling headaches forced him to be invalided home in 1941. He became a diplomat and MI5 secret agent, spending much time in the USA liaising with chiefs of staff, and had reached the senior rank of Wing Commander by the time he left the RAF in 1946.

The writing career he craved did not come easily. His adult fiction didn't quite work and he had to churn out a lot of pulpy short stories and hack Hollywood scripts

to fund his expensive lifestyle. In 1953 he married American actress Patricia Neal (1926–2010), a trophy bride for his ego that only ushered in more tragedy. In 1960 their baby son Theo was left brain-damaged after an awful New York street accident; in 1962 their daughter Olivia died of measles at age seven; and in 1965 Neal suffered three catastrophic strokes while pregnant with their fifth child. Simultaneously more embittered and more motivated, Dahl worked round the clock to put things right. He helped design a valve to drain fluid from Theo's brain that became the standard valve for hydrocephalus around the world, and, even though doctors had written her off as a severely disabled, he so effectively bullied and cajoled Neal into regaining her health that, scarcely credibly, she was able to return to acting (Neal would eventually lose patience with his womanising and his moods and they divorced in 1983). In adversity he turned to writing for children – the suffering innocents he had always preferred to adults – and thereby found his muse, transforming children's literature forever with a string of bestsellers. And with these delicious, subversive folktales for the twentieth century, classics such as *James and the Giant Peach*, *Charlie and the Chocolate Factory*, *Fantastic Mr Fox*, *The BFG*, *The Witches* and *Matilda*, the boy who never really grew up confirmed the truth of a timeless maxim: no grit, no pearl.

Earth

Cardiff's primary, priceless asset is its soil: damp, alkaline river alluvium and grit on bedrock of Triassic red marls. There could hardly be a better medium for growing plants than this wonderful free gift. Indeed, the fecund fertility of the Taff/Ely/Rhymni delta was as much a factor as strategic position when various invaders and colonisers chose Cardiff as a site for their garrison. The sweet, dark earth remains good stuff, but since the Industrial Revolution an alarming 60 per cent of Cardiff's soil has been permanently eliminated. It takes around 500 years for just one inch of topsoil to be formed naturally. Given the instability and unsustainability of the global market in food, this loss is profound and serious.

The abundant, high-yield market gardens and kitchen gardens of pre-coal Cardiff have long gone (Canton was known as 'the garden of Wales' until the mid-nineteenth century), while apartment blocks and multi-occupied houses in the inner city plus 'garden grab' for extensions and car parking in the suburbs have left most Cardiffians without a patch of earth to call their own. However, the popularity of Cardiff's allotments reveals how our agricultural ancestry bubbles just below the surface. There are twenty-five allotment sites across the city and most have long waiting lists. The sites most in demand are the Pontcanna and Llandaf Fields allotments off Western Avenue which are lovely oases of tranquility where bees buzz on the compost heaps, siskins forage in the hedgerows, and wine glasses clink in the tumbledown summerhouses.

There are still a few places in Cardiff where unadulterated, unmolested topsoil uncorks marvels, places like the Fforest Ganol Nature Reserve (one of just five Nature Reserves in the city – the others are Cardiff Bay Wetlands, Flat Holm, Fforest Farm and Howardian). Fforest Ganol is the most westerly native beech wood in the UK, an ethereal cathedral of trees climbing the north-west hills of Cardiff between the steep gorges of the Taff and the Cwmnofydd. Not 5 miles from Queen Street, here one can get completely lost under the majestic canopy, with only elusive hawfinches and crossbills and carpets of wild garlic and orchids for company.

Another example is Bute Park. Left to its own devices, Cardiff would revert to thick forest. When trees get their roots into the meaty wet sediments they thrive and grow to

Llandaf Fields.

giant proportions, and Bute Park is the best place to see this spectacular copiousness. Originally the grounds of the castle, laid out by Lancelot 'Capability' Brown (1716–83) in 1777, Bute Park came into the city's hands as late as 1947. Two hundred years of careful and varied arboriculture have produced a magnificent, spacious treescape, much of it planted out by Lord Bute's head gardener Andrew Pettigrew (1833–1903) in the 1870s and 1880s. There are examples of paulownia, pterocraya, juglans, acer and idesia that are the biggest in height and girth of their species in the UK, as well as 100-foot redwoods, evergreen oaks, an avenue of ginkgos and, across the river in Pontcanna Fields, a boulevard of limes marching north to a distant vanishing point at Llandaf Fields.

There are more champion trees in Roath Park (Magdeburg apple, Japanese red pine, Pyrenean oak), Roath Brook Gardens (nettle tree, Dieck's maple, honeysuckle), Roath Mill Gardens (white mulberry, Oliver's lime, Oriental sweet gum) and Victoria Park (spindle tree, whitebeam, American lime), while up in the hills at Parc Cefn Onn the acid soils nourish a rare collection of firs, pines, junipers, spruces hemlocks, maples and cypresses, towering in aromatic coniferous groves.

Fairwater Park Pond

Fairwater Park opened in 1959 in the grounds of 1845 Fairwater House (demolished 1993), previously part of the estate of the David dynasty. In a lofty position on steep, wooded slopes cut by the V-shaped ravine of the Nant Tyllgoed on its route down from Coed-y-Gof to join the Ely at the medieval mill, the park has a circular pond in a shady bower at its summit. Stone-lined, it is not natural but a rainwater-filled residue of Fairwater House's ornamental fish ponds and an important oasis of biodiversity.

Flat Holm

Smalls Rock on the Pembrokeshire coast is the westernmost point of Wales; Ynys Badrig off the coast of Anglesey is the northernmost; Lady Park Wood in the Wye valley is the easternmost; and the southernmost is Flat Holm, Ynys Echni, Cardiff's very own island in the turbulent Severn Estuary.

Flat Holm has been a part of Cardiff since boundaries were first thought necessary in the twelfth century, so it was a shock in 2013 when the council proposed selling it to save £150,000 in annual running costs. This attack on the public realm in the furtherance of 'austerity' was an attack too far for the people of Cardiff and widespread outrage forced the council to backtrack. An action plan followed, full of dispiriting formulations like 'increase footfall', 'branding and marketing', 'visitor packages', 'helicopter trips', 'glamping', 'stag and hen do's' and 'Flat Holm's offer'. The most obvious solution – do nothing at all – seems not to have occurred to them. For now, until the council get that obligatory revenue stream flowing, the island remains an invaluable community asset, its maintenance and protection largely reliant on unpaid volunteers, charity and the Flat Holm Society.

Less than half a mile wide and with a circumference of just over a mile, the 35-hectare (85-acre) carboniferous limestone disc sits low-slung on the Severn Sea, rising gently from a wave-worn, rocky western shore to a 32-metre (105-foot) eastern apex topped by a lighthouse. It is quite different to neighbour Steep Holm (Ynys Rhonech) 2 miles south, a jagged plug jutting 60 metres (200 feet) out of the ocean. Steep Holm is in

England (Somerset); the two Holms thus invert the usual Welsh highland/English lowland dichotomy.

Flat Holm is a nature reserve, a designated Site of Special Scientific Interest and a wild bird Special Protection Area, home to large breeding colonies of gulls, oystercatchers, shelduck, slow-worms, rare butterflies and wild sheep, living in a sublime seascape of telescopic vistas, tempestuous weather systems, enormous tides and ravishing sunsets. Botanically, it features succulent, salt-resistant maritime grasslands, swathes of sea lavender, wild peony and stonecrop, and very rare clumps of wild leek, their stiff purple-flowering heads jousting and jerking in the summer breeze.

Flat Holm also seeps with atmospheric history. Many of the most influential early Welsh Christians, such as Dyfrig (*c.* 425–*c.* 505), Cadoc (*c.* 497–*c.* 580), Gildas (*c.* 500–*c.* 570) and David (*c.* 530–*c.* 589), used it as an ascetic retreat in the 'Age of Saints'. During his time as a hermit on Ynys Echni, itinerant monk Gildas conceived *De Excidio Britanniae* (*Concerning the Ruin of Britain*), a scathing polemic against the coming of the barbarian Saxon hordes. It is one of the very few accounts of the period actually written by a contemporary and, because the issues Gildas raises are yet to be tackled let alone resolved, his work still nails enduring British realities an amazing 1,500 years later.

Viking marauders occupied the island in the tenth century, providing it with today's English name; the overlords at Cardiff Castle allowed tenant farmers to build the first farmhouse in the twelfth century; pirates used it as a lair in the fourteenth century; smugglers hid contraband in the caves in the seventeenth century; and in 1737 feral Flat Holm began to be tamed when a Bristol merchant paid for the erection of a circular, stone, tower lighthouse in response to frequent shipwrecks in the treacherous sea lanes. Trinity House bought the lighthouse in 1822 and raised the tower's height to 30 metres (98 feet). In 1929 it was further modernised to accommodate four keepers, all made redundant in 1988 when the lighthouse was automated. Now the graceful white pharos is controlled from an operations centre in Essex and runs on solar power.

In 1869 Flat Holm was among many sites around the British coast fortified for a naval war with France that didn't happen. A barracks for fifty soldiers was built near the lighthouse, four gun pits were constructed, cleverly rendering the gun batteries invisible to shipping despite the low-lying terrain, and a unique rainwater catchment system of gathering slopes leading to an underground storage tank was installed to provide water. It was all unnecessary: the guns were never fired in anger and the barracks never housed more than six men until briefly brought back into emergency use during the Second World War. The virtually intact four batteries and associated military bits and pieces are still strewn across the island, while the fine stone barracks complex was restored and converted into a museum and educational centre by the council's Flat Holm Project in 1997. The barracks also include a little pub, the Gull & Leek, which opened in 2011 (Flat Holm's second inn, the enlarged farmhouse, was converted into the Flat Holm Hotel in 1897 but it closed by 1910, possibly for want of passing trade).

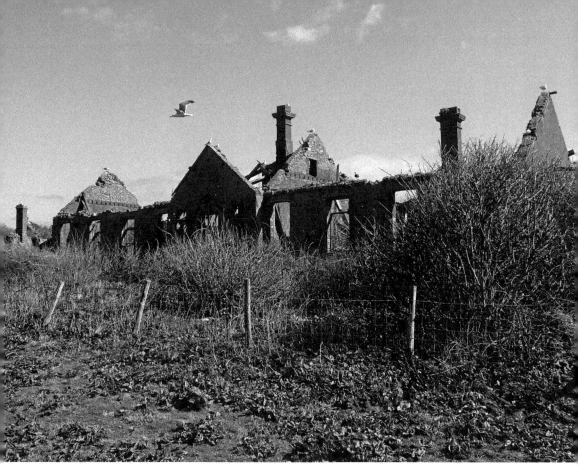

Cholera hospital. (Cardiff Council Flat Holm Project)

Flat Holm's isolation was exploited in 1883 when a small cholera hospital was built near the farmhouse and then expanded into a full-scale cholera sanatorium in 1896 to try to protect the mainland population from repeated epidemics. The hospital closed in 1935 and slowly disintegrated into today's poignant, Grade II-listed roofless ruins.

In 1897 Flat Holm came to wider attention when Guglielmo Marconi (1874–1937) on Lavernock Point near Penarth, transmitted the first wireless communication across open sea to his assistant George Kemp (1857–1933) stationed 3 miles away on Flat Holm. Their groundbreaking conversation by radio waves ('Are you ready?') was a suitably trite start for the technology that would usher in the Wi-Fi of today.

Flat Holm's busy phase came to a close in 1906 when Trinity House added an elegant Foghorn Station, the last new building to be erected on the island to date. The throaty blasts booming through the Severn gloom were still audible in Cardiff until 1988, but then the station was decommissioned. Following a complete restoration in 2000 by the Flat Holm Society working with the Assembly, the Grade II-listed building now functions again, and that resonant sound once more shudders through the city on foggy nights.

Getting to Flat Holm necessitates an exciting 50-minute crossing from the Barrage (between April and October). The farmhouse, greatly altered but still squatting

against the prevailing winds on its ancient foundations, has been renovated and modernised into accommodation for overnight visitors, while two solar arrays and a wind turbine installed in 2007 supply the electricity previously provided by clanking diesel generators. For day trippers there are three hours to explore before the boat departs on the next tide. The time flies: one would need a lifetime on tiny Flat Holm to know it fully. The wondrous isle is packed with historical, geographical, geological, biological and anthropological interest.

Grangetown Gasholder

The disused gasholder at Ferry Road, Grangetown, is one of Cardiff's most spectacular structures, a gargantuan, 150-foot (45-metres) high, metal cylinder supported by a double tier of sixteen cast-iron Doric columns linked by lattice girders and slender cross braces. This supremely confident Victorian masterclass in how to combine the utilitarian with the decorative dates back to 1881 and, once one of six gasholders at the Grangetown gasworks, is now the last gasholder standing in Wales.

Thankfully, as a Grade II-listed building it's protected from demolition when the gasworks site is cleared for a planned high-density housing development. By utilising a brownfield site, decontaminating polluted ground, extending Grangemoor Park, creating new pedestrian and cycle routes to the Ely trail and preserving the gasholder as an improbable, unique centrepiece, the mooted development promises to be a change for the better.

Gas for street lights first came to Cardiff in 1821 with a modest gasometer on The Hayes before, in 1837, the Cardiff Gas & Coke Co. opened a full-scale gasworks on Bute Terrace. Despite being enlarged in 1847, 1851 and 1854, the works couldn't keep pace with the exponentially rising demand of the growing town, so the company built brand-new gasworks in open countryside at Grangetown in 1865. The location was perfectly positioned for coal supplies from the valleys, tucked into the wedge between the bifurcating embankments of the 1859 Penarth Railway from Radyr to the Ely tidal harbour and its 1865 branch to Penarth Dock that had just been constructed across the pristine tide fields and lush grasslands. At its peak in the 1920s, before technological advances brought gas from afar by pipelines, the gasworks employed over 500 men and was an integral part of Grangetown's proudly proletarian, blue-collar identity.

The Bute Terrace gasworks eventually shut in 1907, and that site's subsequent story is a good example of the randomness of Cardiff's evolution. Rusting remnants of gas manufacturing were removed bit by bit while remaining buildings were retained as the Cardiff Gas Company's offices until nationalisation in 1949 set up the Wales Gas Board, the first publicly owned pan-Wales industrial undertaking. The Gas Board built new headquarters, Snelling House, on the east of the plot in 1963 – Cardiff's first dabble with out-and-out modernism – and sold the rest for an office development,

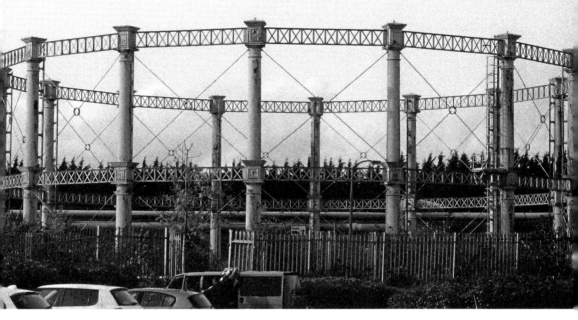

Grangetown gasholder. (Seth Whales)

Harlech Court, built atop the solid stone original offices. Then privatisation of the gas industry in 1986 rapidly led to today's 'energy market' of global cartels outsourcing dirty work to low-wage economies and the end of gas production in Cardiff. Bute Terrace's 162-year-old gas connection was finally cut in 1999 when Snelling House became the Big Sleep Hotel – but the walls of sturdy Pennant sandstone coursing under Harlech House are still there to give today's dual carriageway some gravitas.

Likewise, the Grangetown gasworks didn't survive in the world of profit-hungry rationalisation and it shut down in 1997 after 132 years. The goods line to the River Ely closed and its embankment was flattened in stages for housing, the gasworks access lane (now Fleet Way) to Penarth Road under the surviving Penarth line was blocked, IKEA opened a superstore at the northern end of the site in 2003, and the rest was left to quietly rot into Cardiff's last large zone of strangely appealing post-industrial dereliction. Now the owners, National Grid and Wales & West Utilities, are cashing in their chips and soon this corner of Cardiff's West Moors will welcome its first ever inhabitants. Subject only to the limits of imagination, the great gasholder has a future of intriguing possibilities.

Hamdryad

How the exotic word 'hamadryad' found a home in Cardiff is a fine example of the law of unintended consequences in action. In classical Greek mythology a Hamadryad was the spirit of a tree, a special sort of dryad or wood nymph. From that source it sprouted various other meanings: a king cobra (the world's longest venomous snake); a butterfly genus; an Asian baboon; and an otherworldly entity in a range of genre fiction works, from the macabre mysteries of Edgar Allen Poe (1809–49) and the children's fantasies of C. S. Lewis (1898–1963) through to the sci-fi futurisms of Barry-born Alistair Reynolds.

The four-syllable mouthful, a resonant catch-all to vaguely denote leviathan menace and pantechnicon enormity, was also adopted by the Royal Navy seeking evocative new names for its many warships in the eighteenth and nineteenth centuries. The third ship to use the title HMS *Hamadryad* was a 46-gun, fully-rigged sailing frigate built at Pembroke Dock, launched in 1823. Based in Plymouth, the 45-metre- (150-feet-) long, iron-clad, oaken sea monster rarely left Devon and was eventually deemed redundant as the age of steam superseded the age of sail.

The ship was earmarked for the shipbreakers when borough medical officer Henry Paine (1817–94) intervened in 1866 and brought it to Cardiff to act as a seaman's hospital for the treatment of infectious diseases cholera and smallpox then rife among the transient nautical population. The dynamic Paine got the idea from the way two other obsolete warships had recently been given new purpose in Cardiff: HMS *Thisbe*, moored in the Bute West Dock from 1863 as a floating church for seamen (broken up in 1892 when replaced by the huge Mission to Seamen church beside the West Dock Basin, itself demolished in 1990); and HMS *Havannah*, berthed on the east bank of the Taff south of the Penarth Road bridge from 1865 as a 'ragged school' to train poor, homeless boys for a life in the merchant navy (broken up in 1905).

The hulk was beached on the mud near the entrance to the Sea Lock of the Glamorganshire Canal and next to the elegant, narrow, wooden trestle swing bridge across the Taff, built in 1861 by the Taff Vale Railway to link Butetown with Grangetown and, via a ferry across the Ely, Penarth Docks (it was dismantled in 1892 after being usurped by the 1890 Clarence Road Bridge a little upstream). By 1871 the

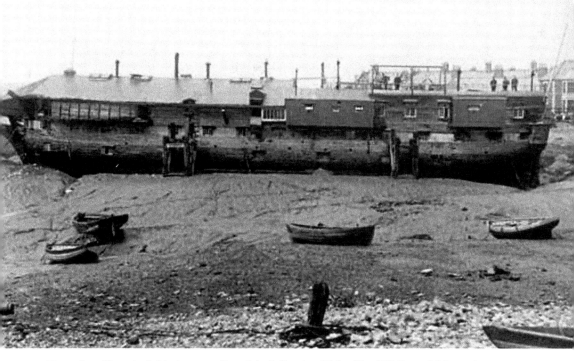

Hamadryad hospital ship in 1900. (People's Collection Wales/Cardiff Central Library)

hospital ship had opened its gundeck wards to all the ill of Cardiff – the only centre for treating infectious diseases in the town.

Paid for by voluntary contributions and a 2s levy on every 100 tons of registered shipping that entered Cardiff Docks, the eerie antique mouldered in mud at the mouth of the Taff for forty years until replaced in 1905 by a permanent building, the Royal Hamadryad Seamen's Hospital. The *Hamadryad* had hit dry land at last. When the ship was broken up millions of rats were released from its barnacled bowels onto the land, an infestation that caused the soggy isthmus to be known as 'Rat Island' for generations to come.

The new hospital was built on reclaimed salt marsh overlooking the mouth of the tidal Taff on what was still called Ferry Road despite the link to the Ely ferry having been severed. It was a stylish neo-Jacobean confection of brick, stone and tile in many shades of red, a distinguished addition to the architecture of Cardiff by EWM Corbett (1849–1934). Incorporated into the NHS in 1948, the Royal Hamadryad Hospital survived numberless reorganisations and rationalisations to become a psychiatric and geriatric facility until finally closing in 2002. Unforgivably, most of Corbett's work was then demolished and only the façade on rechristened Hamadryad Road was retained to front a small mental health unit. As night follows day, plans to construct fifty-five 'affordable' homes on the cleared land to the rear have been duly nodded through by the council.

Thus the Cardiff association of Hamadryad with medicine was ended; but the wonderful word lives on in the city in ways unimaginable when the hospital ship

was first towed up the Taff 150 years ago. A positive side effect of the 1999 Cardiff Bay Barrage was the gaining of land from the sea at the northern edge of the Bay. What was mud flat and salt marsh was laid out as Hamadryad Park in 2002, a 14-hectare (35-acre) open space created in the small print of the Barrage Act as a green sop to wrong foot environmentalists. It's an airy, pleasing place, luminous with liquid light reflecting off the water and offering broad views and new perspectives on Cardiff and the Taff. There are immature thickets taking hold and a startling, bowl-shaped lagoon connected to the river by a narrow channel. Although it is usually deserted there is little peace and quiet here, pummelled by the constant roar of the Butetown Link cutting through the middle of the park as it rises on concrete pillars to span the Taff.

The eastern half of Hamadryad Park is the Wetlands Reserve, a man-made habitat of reed beds, lagoons, islands and reens for the freshwater flora and fauna tentatively colonising the previously saline world. A 350-metre (1,150-feet) stone 'bund' was constructed along the shoreline just below the surface of the water to break the energy of waves and create the wetlands. From winding boardwalks, gravel paths and platforms, herons, cormorants, swans, grebes and coots can be observed going about their business where dunlins, knots, curlews, avocets and redshanks used to rule the roost.

So, by haphazard happenstance, the lovely word 'hamadryad' lives on in Cardiff – and what wood nymphs there are now have a home in the wind-buffeted saplings finding their feet on the uncertain new ground.

Heath Park Pond

The National Playing Fields Association has now been rebranded as Fields in Trust. House Windsor contributed a princely £25,000 towards Cardiff Council's £105,000 bill for buying the grounds of 1840 Heath House (burnt down 1965). The association has been nominal trustee of Heath Park since 1939 – but royal protection has been of little help to the shrinking heath. Above-ground manifestations of the culverted Nant Wedal that had been made into spellbinding ponds in the 1860s have almost all gone, and the one left has halved in size since the 1950s and is now coveted by the Cardiff Model Engineering Society. The society moved to Heath Park in 1987 and built a miniature railway, open to the public thirteen days a year. The ever-expanding operation will soon have more miles of track in Cardiff than Arriva Trains Wales!

Hendre Lake

Another man-made lake, far out in the south-eastern corner of Cardiff where the flatlands of Gwynllŵg dissolve into the sea. The 4-hectare (10-acre), fish-thronged lake, set in a public park, opened in 1980 as an amenity for the new St Mellons Estate, is fed by the waters of the Pill Du and Faendre reens, drainage ditches that date back

to Roman times. Maturing nicely, it has its own proper island where water birds nest and breed, oblivious to the trains shrieking past on the mainline railway to the south.

Howardian Nature Reserve

In 1973 Cardiff Council granted a defunct waste tip to nearby Howardian High School for educational purposes and, by the time the school closed in 1990, the land had been skilfully returned to its natural damp woodland habitat. Since it had no economic use it was designated a nature reserve. Today few people come to this otherworld where stands of ash, willow, hawthorn and rowan are bestrewn with a number of frog-hopping mini-ponds (one containing Cardiff's smallest island), fed by a trickling rivulet with a waterfall that runs down from the allotments before sinking into the sticky clay. Over 500 species driven out of their ancestral places by Cardiff's incessant growth have made a home in these unwanted wet wastelands.

Ifor Bach

In the twelfth century the Welsh kingdom of Morgannwg was a war zone. The native Welsh were fighting a desperate defensive campaign against the invading Normans who had seized the lowlands and built a chain of mighty forts from where they could savage incursions into the unconquered uplands. One of the greatest rebel leaders in the area was Ifor ap Meurig (c. 1130–c. 1169), known as Ifor Bach because of his diminutive stature. Ifor (pronounced ee-vor) was lord of Senghennydd, one of the five cantrefi of Morgannwg. The lordship of Senghennydd originally stretched from the Severn to the Brecon Beacons, but by 1150 the Normans had seized the fertile southern coastal plain, including Cardiff, and Ifor's lands had been cut back to the wild mountain strongholds.

Ifor retaliated spectacularly in 1158 by striking at the heart of Anglo-Norman power in Morgannwg: Cardiff Castle. The largest motte in Britain, raised in 1090 after Cardiff was captured, had just been further strengthened into a massive masonry tower with surrounding battlements and moat, the very symbol of invincibility. Inside the castle resided the military commander and usurper lord, William FitzRobert, 2nd Earl of Gloucester (c. 1121–1183), along with his family, 120 troops and a guard of archers. Yet these state-of-the-art fortifications failed to stop Ifor.

According to Gerald of Wales (c. 1146–1223), writing only a few decades after the event in his groundbreaking travelogues *Itinerarium Cambriae* (1191) and *Descriptio Cambriae* (1194), Ifor scaled the walls of the castle in the middle of the night, snatched the earl and his family from their beds and spirited them away to his bastion in the high forests. Showing a humanity that was never reciprocated, he then returned the hostages unharmed after receiving guarantees the stolen land would be restored. That, it turned out, was Ifor's mistake.

The rest, as they say, is history. Senghennydd fell by 1275 and eventually, after 300 more years of resistance, all of Wales was conquered and annexed by England. Ifor's far-off exploits faded further and further into the mists of time, kept alive as oral anecdote passed through the generations until maturing into folklore, perhaps because the characteristics he manifested came to typify many strands of ongoing Welsh identity: the little guy, the ultimate underdog up against overwhelming odds,

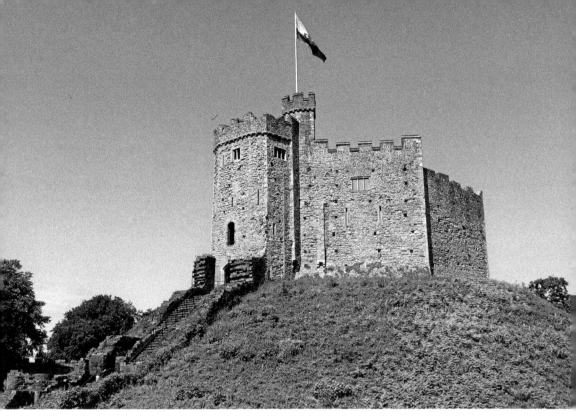

The Cardiff Castle keep which Ifor climbed. (Wolfgang Sauber)

armed with nothing more than boldness and wit, equally cursed and blessed by gullibility and cock-eyed optimism.

In 1983, in a stroke of inspiration, the Welsh language activists and musicians of Cymdeithas Clwb Cymraeg Caerdydd, led by Owen John Thomas from Roath (later a Plaid Cymru AM between 1999 and 2007), gave Ifor Bach's name to the new music club they were opening in an old British Legion building in Womanby Street. Clwb Ifor Bach rapidly became the epicentre of bilingual Cardiff as well as the best live music venue in the city, a ceaseless champion of diversity and excellence, a position it still maintains after nearly thirty-five years – in itself an unprecedented lifespan for a Cardiff club. Moreover, in Ifor's spirit of audacious rebellion, the Clwb's relaxed, welcoming, all-embracing, very Welsh vibe has effortlessly silenced the old lies about 'parochial' and 'insular' Wales. So the flickering flame of Ifor's fight to right wrongs still burns in Cardiff, just a stone's throw from those walls he climbed 850 years ago.

Jones

In 2006, 1,224 people with the surname Jones attended a concert at the Wales Millennium Centre, aiming to break the world record for the largest gathering of people with the same surname. The record was duly broken – not too difficult a task, given that nearly 150,000 Welsh people (1 in 20) are Joneses, making Jones the most common surname in Wales, and Wales the country with the highest density of Joneses in the world.

It was all just a bit of fun. There were contributions from the usual Jones suspects (e.g. Tom, Catherine Zeta-, Aled, Ruth and, er, Grace), and TV channel S4C got an hour of light entertainment out of it. However, leaving to one side the fact that a galaxy of 1,488 Gallaghers congregated in Ireland to beat the record again just a year later, the event glossed over the serious origins of this archetypal Welsh surname.

When Wales was annexed by England in 1536 the Welsh language was effectively made illegal by a range of penalties, punishments and restrictions on its use. Up until then the Welsh didn't have surnames. Instead, there were a vast range of forenames which, when necessary, were linked to the father's, grandfather's and great-grandfather's forenames, ad infinitum if genealogically desired, by using the word ap/ab ('son of') or ferch ('daughter of'). Forced to Anglicise, or else, the people were quickly coerced into dropping all the wonderful multiplicity of Welsh forenames and giving their children English forenames instead, the better to fit in and stay out of trouble. Because nearly everyone was entirely monolingual and had little knowledge of English, and because bland anonymity was expedient in order to survive, only the commonest English forenames were used: names like David, William and John. John was a particularly alien word: there isn't even a 'j' in Welsh.

But the ancient patronymic system dating back to the laws of Hywel Dda (c. 880–950) was not so easy to bully out of existence. It remained the underpinning foundation of Welsh nomenclature. In a classic Anglo-Welsh hybridisation, to provide what was now an obligatory surname the routine English forenames were given the Welsh forefather treatment, but fixed rather than added to down the generations. So, if the father's forename was David the child's surname was Davies, William begat a Williams – and John a Jones. As was the case with many of the surnames allocated to slaves by

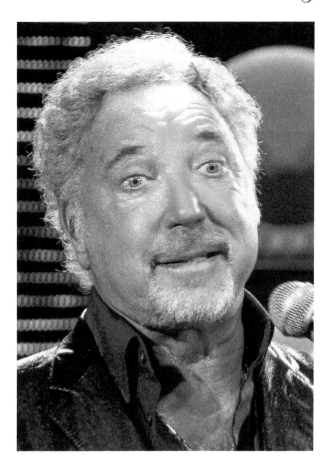

Wales' best-known Jones.
(Ger1axg)

slave owners, the 's' here is actually the possessive form (minus the apostrophe), not a plural. In Wales, 'Keeping up with the Joneses' wasn't today's idiomatic mocking of anxious social climbing and shallow consumerism; it was a way of life.

Hence Wales still has an unusually small range of surnames, all derived from forenames and nearly all ending in 's'. The top ten surnames are, in descending, order: Jones, Williams, Davies, Evans, Thomas, Roberts, Lewis, Hughes, Morgan and Griffiths – ten surnames that cover an astonishing 35 per cent of the population. 'Jones' is thus a vivid symbol of Welsh dispossession and subjugation.

Kairdiff

The accent of working-class Cardiff, an adamant, clipped, downbeat, nasal rasp long deplored in the posh parts of town, has never received much of a hearing. The only people currently voicing it in the mass media are musical sage Frank Hennessy (from Rumney) on BBC Radio Wales, football commentator Mark Jones (from Grangetown) on S4C, and the wonderfully feisty and politically engaged Charlotte Church (from Llandaf). Those three alone, all indispensible in their own way, show that 'Kairdiff', with its inbuilt fluidity, loquaciousness, inventiveness and clarity, is the perfect verbal vehicle for broadcasting, yet the cultural gatekeepers have ignored and sidelined it so comprehensively that the highly distinctive accent is one of the least known in the UK. Why? Lots of reasons: its non-hierarchical roots, mongrel ingredients, democratic essence, unapologetic non-conformity, street authenticity, proud proletarianism and disrespectful two fingers thrust in the general direction of 'received pronunciation' – and that's just for starters.

Combining Welsh lilt, Devon burr, Somerset buzz, Black Country twang and Irish brogue, the delta dialect is a dog's breakfast of phonetic curios, unique to south-east Glamorgan. As with every accent, it is all in the vowels. Compressed or distended, sharpened or squashed, lazily elided or thumpingly overemphasised, they are bent to suit the gallop and gush of the gobby, garrulous, gatling-gun delivery. 'A' above all; best exemplified by the stock 'Aarf a Daark in the Old Aarcaade aafter Caardiff Aarms Paark' mimicry that has supplied gentle amusement during conversational lulls at Cyncoed dinner parties for decades. 'A' is always hard, as hard as an uncut diamond: 'castle' rhymes with 'hassle' not 'parcel'. Note too, that the underpinning Welsh gives the vernacular tongue seven vowels to play with (as heard in words like 'here' and 'girl' and 'turn' and 'who' and 'look' and 'tooth' and, yes, 'Cardiff'), and thereby also generates a trove of boundless diphthongs crying out to be fashioned into new noises.

While the parody word 'Kairdiff' suggests non-Welshness (there being no 'k' in Welsh) and Welsh 'received pronunciation' is treated with the same casual contempt as English, quirks in syntax and grammar underline the Welsh well-spring of the accent – hardly a revelation since Cardiff is in Wales, but always worth stressing to counteract the abiding lie, delusion or myth that Cardiff somehow landed here from

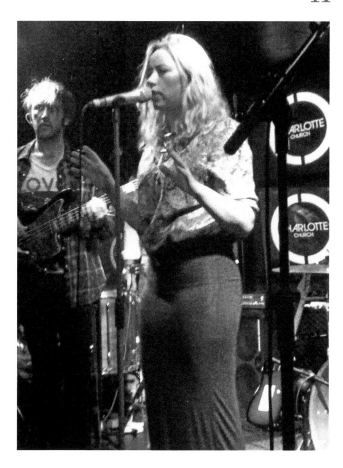

Charlotte Church.
(BrotherDarksoul)

outer space. Formulations like 'I loves you' or 'I do do' or 'over by there' or 'where to', for instance, are simply ghosts of the lost language (in these examples, the fixed verb-noun that disregards the pronoun, the be/do auxiliary in the present tense, the double preposition and the active preposition), and mutant vestiges of vocabulary litter the lingo, from cracking to cwtch, bad to tad, tidy to ych a fi.

Like many hyper-local accents in the UK, the Cardiff accent is an endangered cultural phenomenon. Traditionally it petered out suddenly depending on how far north, east or west one got from the urban inner city; but, due to social engineering, deindustrialisation, slum clearance programmes, gentrification, studentification, commercialisation and Anglo-American homogenisation, it's rare these days to hear unreconstructed Kairdiff within audible range of the City Hall clock.

Lamby

Near where Lamby Way crosses the River Rhymni, there is a gap in the hedge which gives access to a (prohibited) path that climbs the flanks of a the old Lamby Way corporation tip, a capped, landscaped man-made mountain built of forty years of Cardiff garbage.

At first tracking the extravagant meanders of the tidal Rhymni, twice daily transformed from a lazy trickle between glistening banks of devouring mud to an ocean-driven surge barrelling up the valley, the path then twists through whispering willows to reach an extraordinary summit plateau: the sole place where one can obtain a view of Cardiff from the south – a point-of-view normally reserved just for the seagulls gliding silently overhead.

The view is particularly spectacular on a clear night with a rising moon, when Cardiff's gaudy box of tricks metamorphoses into a choreography of spangling luminosity sighing under the stars. In daylight the residential streets that are the city's predominant environment down on the ground take centre stage and sharpen into focus in the maritime magnification.

Lisvane Reservoir

Completed in 1869, the 8 hectare (20 acre) Lisvane Reservoir provided Cardiff's first public water supply (Cardiff's first reservoir had been the privately owned 1853 Penhill Reservoir, dismantled 1955). It was carved out of the gentle uplands by damming the Nant Fawr and the Nant y Felin as they rushed down from their gurgling sources on Wern Fawr hill and entrapping the water within immaculately constructed grassed embankments. Too small for a big city, it was eventually made redundant in the 1970s. By then it was an important recreational amenity near the head of the green Nant Fawr corridor and a designated SSSI for its wintering wildfowl and grassland fungi (*see* Llanisien Reservoir *below*).

Llandochau

'Llandough' is one of the most contemptuous bastardisations of a Welsh place name in all of Glamorgan – which is saying something. Leaving to one side the 'au' suffix, routinely used in names like Caerau and Pontprennau anyhow, the Welsh 'ch' is very easy, and very close to the way everybody pronounces it ('Llandock'). The very English 'ough', though, is extremely difficult to get right, being notorious as an entirely unphonetic string of letters with seven possible pronunciations. Victorian map-makers from London imposed this travesty, giving 'ough' a ridiculous eighth version never used before or since. Llandochau is home to one of the great artifacts of Celtic Christianity, the intricately carved tenth-century Irbic Cross in St Dochdwy's churchyard, site of a fifth-century Welsh llan – the venerable origin of the name now routinely traduced by Vale of Glamorgan Council.

At the rear of the 1933 hospital is the ideal place to get a Cardiff eyeful from the west, high on the cliffs of Triassic marls above the River Ely. Due to acoustic ricochets, Cardiff is noisy and pungent from this angle, moaning and hissing under its smothering shroud of pollution. The Wales Millennium Centre, just three-quarters of a mile away, again grabs attention. Rather like Uluru (Ayers Rock) in Australia, Jonathan Adams' metaphor-laden building can appear to change colour depending on the atmospheric conditions. It's no armadillo; it's a chameleon. In a bleached, pale, afternoon blur the bronze panels become unexpectedly silky black, as if rejecting a sky that will not let them glint.

Llanisien Reservoir

Four times bigger than Lisvane Reservoir, Llanisien Reservoir was constructed immediately to the south and opened in 1886. As Cardiff's exponential growth went off the graph it too was soon inadequate, superseded by huge reservoirs in the Brecon Beacons, and left to become a marvellous public recreation asset and wildlife haven. Following the Thatcher government's privatisation of water in 1989, the two reservoirs were tossed around between corporations until falling into the hands of American conglomerate Western Power Distribution (WPD) in 2000. Reacting outrageously to repeated refusals by the council and the Assembly to let them fill in most of the reservoirs and build 300 completely unnecessary speculative mansions, WPD blocked public access in 2004 with a bellicose spiked steel fence around the entire circumference, plastered in warning signs informing Cardiffians accustomed to wandering up here for over a century that this was 'Private Property'. WPD used every weapon in their considerable armoury to try to bludgeon their proposals past massive opposition, culminating in the outlawing of fishing and sailing and the complete draining of the Llanisien Reservoir. They only admitted defeat in 2013, by which time the magical location was a muddy

Llanishen Reservoir, drained. (Matt Lewis)

travesty. Celsa bought the reservoirs to guarantee a water supply to their Castle Works on East Moors Road and the development proposals were scrapped. Now Dŵr Cymru (owned by Glas Cymru, a 'company limited by guarantee' with no shareholders and an obligation to reinvest surpluses in the business) has been granted a 999-year lease by Celsa and the reservoirs at last are safe after a wasted twenty-five years. They have returned to their roots as a public utility, and to the purpose for which they were built: containers of water. Llanisien is to be refilled, but it could take as long as five years. Meanwhile, the delights of the bigger reservoir can be experienced once more. Hidden from all vantage points by the contours of the land until you're practically upon it, with the overflow brook diverted around the west flank in a stone-lined culvert thundering down breakneck chutes, it features marvellous workmanship of narrow seams of Pennant sandstone, a palpable aura of peace and solitude thanks to no overlooking buildings, cormorant-built islands, majestic pines standing sentry in secret clearings and a luminous limpid light melting into moody skies.

Llyn Tredelerch

Parc Tredelerch, opened in 2003, was created thanks to pressure from local people desperate for green spaces (they also chose its Welsh name in a ballot). It has a 4 hectare (10 acre) lake, a vast range of moisture-loving plants quickly establishing themselves and freshwater birds galore, including mute swans – the 'alarch' after which it is named. The boardwalks and paths around the lake trace what was once an extravagant meander of the River Rhymni until it was straightened out as part of the Lamby Way roadworks in the 1970s. On the other side of the roundabout at the Lamby entrance is a further lake, a curious, miniature, reed-ringed relic of the Rhymni's wanderings.

M

Musicians

A selected list of musicians born, or bred, in Cardiff:

Arran Ahmun (born 1956)
Drummer from Butetown who has worked in top backing bands for over four decades, having a particularly long association with Scottish chill-out sensualist John Martyn (1948–2009).

Steve Andrews (born 1953)
The new-age noodlings of shaman/druid/herbalist the 'Bard of Ely' reach the global counterculture via the internet.

Arthur Angle (1875–1943)
The first Cardiff musician to win a local fan base, Roath violinist Angle's chamber concerts at the YMCA and the Carlton were popular among Cardiff's emergent middle classes in the first decade of the twentieth century.

Lincoln Barrett (born 1980)
Drum 'n' bass producer, aka High Contrast, who leapt to prominence with his debut 'True Colours' in 2002. Barrett is one of a number of dance DJs and producers spawned by the Catapult record shop, which opened in 1992 and has grown to become the largest independent in Wales. From behind the stacks of obscure vinyl and racks of painfully trendy clobber in High Street Arcade have emerged the likes of house/trance/breakbeat pioneers Raeph Powell, Neil Hinchley, Shane Morris, Jimpy and Neil Cocker. Today, Bionic, Moneyshot, Midge, Monki, F-Block, Owain K, Hosko, Secondson and Swiss are among the stand outs on the decks.

Shirley Bassey (born 1937)
See under B.

Wally Bishop, aka The Great Waldini, 1959.
(Skrbishop)

Wally Bishop (1894–1966)

Bishop from Canton met the pre-Second World War demand for variety acts as The Great Waldini, playing swooning 'gypsy' violin to courting couples in Roath Park.

Gareth Bonello (born 1981)

As The Gentle Good the bilingual singer-songwriter has propelled the renaissance of Welsh music into the twenty-first century, aided and abetted by wise elder Richard James, the ex-Gorky's Zygotic Mynci maestro. Acts grabbing attention in the folk boom include: The Storys, Gethin Pearson, Huw M, Silence At Sea, Pilots, Sweet Baboo, Soda Men, Toreth, Here Be Dragons, Paper Aeroplanes, Julia Harris, Cymbient, Little Arrow, Dewi Griffiths, Al Lewis, Luke Williams, H Hawkline, Ffred Jones, Denuo and Cate le Bon, all reflecting the urban injection into this ever more diverse genre, while the various projects of Mike Johnson and Gerry Nash are building a new Cardiff songbook rooted in the city's history.

Beatrice Botterill (*c.* 1895–*c.* 1975)

The Welsh folk revival reached Cardiff in the 1950s thanks to Beatrice Botterill from Llandaf, with her harp accompaniments to penillion singing at the Temple of Peace, complete with shawl and stovepipe hat.

Huw Bunford (born 1967)

Guitarist and founder member of Super Furry Animals in Cardiff in 1993, along with Guto Pryce (see below), Gruff Rhys, Dafydd Ieuan and keyboards and samples prodigy Cian Ciarán. SFA sprang from the vibrant Welsh language underground scene that

had cohered in the capital through the 1980s and 1990s, reinventing the old tongue to reflect the reality of an impoverished, besieged country. Seminal trailblazers were the post-punk Ail Symudiad, the orchestral metal of Y Diawled, the distorted ska of Y Ficar, the deconstructed reggae of Maffia Mr Huws, anarcho-punks Anhrefn, the melodic punk of Y Cyrff, the rap-dub of Llwybr Llaethog, the uncompromising experimentations of Datblygu, technology-stretching Eirin Peryglus and Plant Bach Ofnus, the polished harmonies of Beganifs, the techno-explorers Tŷ Gwydr and the pure-pop songcraft of Ffa Coffi Pawb – from whom both Gruff Rhys and Dafydd Ieuan emerged. SFA deftly combined oddball influences, audacious audio and visual experimentalism and a gently warped modernity, stormed the album and singles charts, taking the weirdo Welsh sensibility to astonished audiences and epitomising the easy-going eclecticism of Welsh musicians.

Dave Burns (born 1946)
Grandson of Dan Donovan and a founder member of the Hennessy's (see below), Burns was also one of the founders in 1976 of folk band Ar Log – still one of the biggest live acts in Wales after fifty years.

Paul Chapman (born 1954)
Maendy-born guitarist 'Tonka' Chapman dazzled regulars at the New Moon club in New Street (demolished 1981) and, aged only sixteen, was headhunted by London blues band Skid Row in 1971. He impressed back in Cardiff with Lone Star, but after they split in 1978 failed to live up to early promise by drifting into the world of big perms and stadium rock with bands like UFO, Wasted and Ghost, the latter including Carl Sentance, another Cardiffian into glam-rock.

Charlotte Church (born 1986)
Having topped the classical album charts at the age of twelve with 'Voice Of An Angel', Charlotte tore up the rule book that says child stardom must lead to self-destruction and fear of adulthood. She's down to earth, politically engaged and completely lacking in the vanity, fake modesty or delusions of grandeur of the bog-standard 'celebrity'; while her refusal to move to London has finally buried the idea that Cardiff is a mere staging post and not a destination.

Clare Deniz (1911–2002)
With husband Frank and brother-in-law Joe (see below) pianist Clare Deniz was in the vanguard of UK black music and at the heart of London's jazz scene between the 1930s and 1950s.

Frank Deniz (1912–2005) and Joe Deniz (1913–1994)
The first wave of bohemian Cardiff was represented by a host of talented young jazz guitarists down the docks: inventive talents like the inseparable Deniz brothers

from Tiger Bay, guitarists in the orchestra of Ken 'snakehips' Johnson (1914–1941), a pioneering swing band of black musicians.

Dan Donovan (1901–1986)

Smooth crooner Donovan from Grangetown was the main vocalist with Henry Hall (1898–1989) and the BBC Dance Orchestra in the 1930s. He made over 120 recordings; evergreens like 'Blue Moon', 'Red Sails in the Sunset' and 'Radio Times'.

Dave Edmunds (born 1944)

As beat groups sprang up all over the city in the 1960s, Dave Edmunds from Adamsdown perfected his singing and guitar playing with The Raiders, the first ever band to feature just guitar, bass and drums. Going solo, he was the first male Cardiffian to get to Number 1 with 'I Hear You Knocking' in 1970. With faithful lieutenant Micky Gee (see below) never far away, Dave proceeded to alter the history of pop, laying the groundwork for pub rock, new wave and the rockabilly revival, setting up Wales' first cutting-edge recording studios at Rockfield in Gwent, and resuscitating rock 'n' roll with Nick Lowe and Rockpile.

Maureen Evans (born 1940)

A singer from Rumney who had minor chart entries with a string of covers before getting to Number 3 with the teen-orientated 'Like I Do' in 1962. Follow-up success eluded her as the beat boom took hold.

Dave Edmunds.

Ralph Evans (born 1951)

In 1970 Evans formed Sassafras, a ramshackle collection of wild long-haired hippy boys, with Merthyr's Dai Shell. Their twin-guitar onslaught of 20-minute solos thrilled Cardiff freaks before the hard-gigging band briefly got to the prog-rock premier league in London, appeared on The Old Grey Whistle Test and toured the US. Shell built one of Cardiff's earliest music studios in Severn Road in 1971, a vital facility for the area at the time. Among the other Cardiff prog-rock bands of note in the 1970s were Alkatraz, Good Habit, The Neutrons, Stone Idol, Dozy, Ingroville and Strawberry Dust – all now lost to the microdots of time.

Andy Fairweather-Low (born 1948)

Fairweather-Low from Llanrumney made his name as the baby-faced lead singer of quintessential Mod group Amen Corner, formed in Cardiff in 1966. They had a string of hits with their brassy, good-time pop, featuring his distinctive husky falsetto, and were the first Welsh band to have a UK Number 1 with '(If Paradise Is) Half As Nice' in 1969. Andy went on to a successful solo career in the 1970s before becoming a session guitarist, equally proficient on lead, rhythm or bass, revered by his peers for the sheer breadth of his stylistic range.

Green Gartside (born 1955)

Virtually single-handedly invented 'post-punk' with his band Scritti Politti, formed in 1977. What started as a tinny, dissenting din grew into much more as he discovered melody, polished his honeyed voice, wrote the heckling rhapsody 'The Sweetest Girl' and forged the landmark album *Cupid & Psyche 85*, an influential showcase of sliced beats and inventive use of studio technology. After one of his regular long sabbaticals he reappeared as a performer in 2006 with a new Scritti Politti of shimmering harmonies on a loose, primitive backing.

Micky Gee (1943–2009)

Ace rock and blues guitarist who was a pivotal figure in many bands on the Cardiff scene for over fifty years.

Joe Gregory (1900–1983)

An accomplished accordionist who led a very popular show band in the 1930s.

Tich Gwilym (1951–2005)

Gwilym came to Cardiff from Penygraig in the Rhondda as a young man to work in East Moors steelworks and settle in Splott – that counts as naturalised! Honing his Hendrix-inspired guitar technique in the Royal Oak and the Locomotive, he was content to stay in his beloved Wales, wielding the axe in a series of local bands, like Kimla Taz, Just Good Friends, Superclarkes, Geraint Jarman a'r Cynganeddwyr (see below) and the Siân James Band, before dying in a house fire at Westbury Terrace,

Canton. Tich's enduring memorial is his unforgettable psychedelic version of 'Hen Wlad Fy Nhadau' made with Jarman in Cardiff in 1991.

Frank Hennessy (born 1947)

His band the Hennessy's, formed in 1966 with Dave Burns (see above) and Paul Powell (1946–2007), are still mainstays of the Celtic music scene (Iolo Jones replaced Powell in 2007). Many of Frank's songs have become folk standards, such as 'The Old Carmarthen Oak', 'Farewell to the Rhondda', and the city's nonchalant, secular anthem 'Cardiff Born'.

Owain Arwell Hughes (born 1942)

Son of composer Arwel Hughes (1909–1988), this acclaimed conductor and pillar of the Welsh establishment was born in the Rhondda but raised in Cardiff. The archetypal London Welshman founded the annual Welsh Proms at St David's Hall in 1986 and is still the artistic director.

Geraint Jarman (born 1950)

Geraint Jarman embarked on a musical voyage of discovery after witnessing newly electrified Bob Dylan silence folk-purist hecklers during a gig at the Capitol cinema in 1966. With Meic Stephens of Solva, the godfather of Welsh music, and Heather Jones (see below) he formed irreverent, experimental folk group Bara Menyn in 1969, opening the floodgates for a Welsh musical revival which continues unabated to this day. In the 1970s dynamic Jarman pulled together some of the best musicians in Wales to form Geraint Jarman a'r Cynganeddwyr, ramshackle, lo-fi, new wave adventurers who inaugurated the modern age for Welsh music. The inventive innovator has since evolved into the king of Welsh dub and reggae.

Gwyn Jenkins (1940–2003)

Cathays-born Jenkins, in the advance guard of the 1950s rock 'n' roll revolution, introduced skiffle to Cardiff with his C City Band.

Heather Jones (born 1950)

Heather Jones learnt Welsh as a second language in Cathays High School when the language was at its lowest ebb in Cardiff. She was therefore well positioned to be midwife to the rebirth of Welsh folk music in the late 1960s. Her pure, warm voice gave flower-child idealism to the pioneering trio Bara Menyn, the breakthrough success for the Sain record label. Sain, founded in 1969 in Cardiff (relocated to Caernarfon in 1975), grew into Wales's biggest record company and the very epitome of the independent record label.

Rosemary Joshua (born 1975)

Ely's Joshua has had a glittering, globetrotting career as an in demand international soprano specialising in Baroque opera.

Donna Lewis (born 1973)

The singer-songwriter had a massive hit with 'I Love You Always Forever' in 1996, going down so well in the American soft-rock sector that the mawkish ballad became the most played single ever on US radio up to that point. Since then she has stretched out into trance, house and acoustic.

Lee Marshall (born 1980)

Twiddling knobs and picking guitars to create dense, claustrophobic layers, Fairwater-raised Marshall, aka Underpass, has taken Cardiff electro to heavy new places. Underground, subversive electronica, beyond the grasp of the 'music industry', flourishes in the city: the Access Tonal Communications collective test the outer limits with sonic explorers like Info_Cifon (abstract tones and frequencies), Seko1 (darkcore programming), MrE (circuit bending) and The Hidden Persuader (electro-bass); while Roath's Fourier Transform have released lavishly packaged anti-products that take no prisoners, like the sinister improvisations of Traw, the soothing soundscapes of Hwyl Nofio, or Rhodri Davies's revolutionary approach to the Welsh harp. It's all valid.

Eric Martin (born 1970)

Riverside rapper Eric Martin, aka MC Eric, aka Me One, first established himself with Belgian techno dance project Technotronic in 1990 and is now a songwriter and producer.

Cerys Matthews (born 1969)

In the 1990s the success of the Manic Street Preachers from Blackwood, the biggest-selling Welsh act of all time, brought Welsh music into the mainstream. As the London media 'discovered' more and more Welsh bands, they needed a catch-all phrase under which they could be lumped: 'Cool Cymru' was born. The bilingual indie scene that had been brewing in Cardiff incubated Catatonia in 1992 and they went on to have a string of hit singles, featuring the delirious, pan-Welsh vocals of Cerys, Cool Cymru personified, before reaching their pinnacle with the Number 1 album *International Velvet* in 1998. The title track's line, 'Every day when I wake up, I thank the Lord I'm Welsh', captured the new generation's Welsh pride.

David McNeil (1880–1952)

Influenced by US vaudeville, by 1910 McNeil had become the first Cardiffian to gain broad appeal, performing chirpy ditties under his stage name Nixon Grey.

Jimmy Messini (1908–1970)

A livewire vocalist, guitarist and good-time guy from Tiger Bay who had a fascinating career as the side-kick of famed crooner Al Bowlly (1898–1941) before restless wanderings to the US, Australia and Canada.

Roddy Moreno (born 1957)

The children of the Caribbean immigrants of the 1950s introduced ska, rocksteady and reggae to the city, making deep impressions on intelligent working-class white boys like Roddy Moreno and permeating the punk movement to come. Moreno used his band The Oppressed, formed in 1981 and still going strong, to lead the fight against the bonehead element in punk by starting SHARP (Skinheads Against Racial Prejudice). He's a totemic figure in the international Oi! movement and a hero in anti-fascist circles for his central role in confronting the far right.

Elaine Morgan (born 1960)

Celtic-folk singer-songwriter who began her career with local band Rose Among Thorns and whose close ties with Brittany led to her being the French entry in the 1996 Eurovision Song Contest – who needs the Royaume-Uni?

Lloyd Morgan (born 1974)

Cardiff's turntable king, aka Keltech, has delved into hip-hop and drum 'n' bass with clarity and humour. Where he led others followed, notably the Associated Minds collective and label in Llanedeyrn with passionate and original rappers like Mudmowth, Ralph Rip Shit, Metabeats, Beatbox Fozzy and Ruffstylz in their stable. Welsh-language rap-dub pioneers Llwybr Llaethog have been equally inspiring in Cardiff. Tystion, formed in 1994, picked up their thread and using local MCs and decks stalwarts DJ Jaffa, Little Miss and Johnny B, their 1999 album on *Ankst, Shrug Off Ya Complex*, was a defining statement that helped pave the way for the red-blooded Cardiff hip-hop scene of today.

Keith Morris (1953–2005)

Saxophonist, composer, activist and creative life force who went to university in Newcastle and settled there to become a Geordie jazz hero. He and his friend, fiddler Joe Scurfield (1958–2005), were killed in a hit-and-run incident.

Ivor Novello (1893–1951)

Ivor's biggest hit, 'Keep the Home Fires Burning' (1914), owed much to his knowledge of old Welsh folk melodies (*see* N, Novello).

Tessie O'Shea (1913–1995)

She started singing in the pubs and clubs around Riverside at the age of six, adapting and enduring to become a star in the US in the 1960s. Audiences lapped up her gatling-gun delivery, rictus grin and ukulele-thrashing theme song 'Two Ton Tessie from Tennessee'.

Pino Palladino (born 1957)

Coaxing his signature fretless bass, Palladino, who grew up in Pentrebane, is the bassist's bassist. When John 'The Ox' Entwistle (1944–2002) died suddenly it was Palladino who replaced him in the rock band The Who.

Vic Parker (1911–1978)

Sublimely unbothered by fame, the prodigiously gifted guitarist was content to display his finger-picking virtuosity for a few pints in the Quebec on Crichton Street.

Huw 'Bobs' Pritchard (born 1968)

Described as the 'Billy Bragg of Wales', he gave new impetus to the Welsh protest song in the late 1980s as Byd Afiach.

Guto Pryce (born 1972)

Like all the members of Super Furry Animals (*see* Huw Bunford, *above*), bass player Pryce has been free to develop his own offshoot projects (currently the trippy electronica of Gulp) while SFA continue to operate, going where no band has gone before: the first surround-sound concert, the first simultaneous release of an album on audio and DVD, the first all-Welsh album in the UK charts (*Mwng*).

Burke Shelley (born 1947)

Bass player Shelley formed hard-rocking power trio Budgie in 1967 with fellow Cardiffians guitarist Tony Bourge and drummer Ray Phillips. Budgie originated what would become known as heavy metal, and influenced a host of subsequent metal monsters from Metallica to Queens of the Stone Age, Iron Maiden to Soundgarden.

Jonathan Shorland (born 1968)

A woodwind specialist who helped found folk/traditional band Fernhill in 1996. Along with Carreg Lafar, formed in 1993 in Cardiff, Fernhill were a major factor in the rise of the undervalued Welsh and Breton components of Celtic music.

John Sloman (born 1957)

The Grangetown boy worked on tugboats in the docks while singing with local rockers Trapper and Lone Star before moving to London in 1979 to handle the sword 'n' sorcery vocals for Uriah Heep en route to a long solo career which never entirely fulfilled the promise of his youth.

Alison Statton (born 1958)

The voice of cult post-punk minimalists Young Marble Giants, whose seminal 1980 LP *Colossal Youth* spawned a host of imitators. YMG only existed for two years, but in that time they initiated the next musical leap forward. Statton's cool, dreamy vocals over the soft, clicking rhythms and fragments of melody summoned up by gaunt, reticent brothers Phil and Stuart Moxham out of drum-machine and synthesizers, anticipated the minimalist, rave, electronica and ambient movements yet to come. Statton has been involved in many jazz-pop projects since, including the must-hear 'Cardiffians' (1990) with Ian Devine.

Huw Stephens (born 1981)

Llandaf DJ Stephens exports Welsh sounds via his Radio 1 slots while championing indie music at home with his own labels and his fine music festival Swn. As yet, Cardiff is still to conceive a game-changing major band for him to unearth. Contenders have jostled for attention in the twenty-first century: Derrero, Mo-Ho-Bish-O-Pi, Sammo Hung, Shake My Hand, Jarcrew, The Martini Henry Rifles, Mclusky, Mountain Men Anonymous, Zabrinski, The International Karate Plus, The Loves and Adequate Seven all hinted in the noughties that they might be the ones, but all split before fulfilling their promise. In the last decade Kutosis, The Spencer McGarry Season, RocketGoldStar, Gindrinker, Race Horses, The Witches Drum, Joanna Gruesome, Among Brothers, Shaped By Fate, Threatmantics, Violas, People In Planes, Sibrydion, The Adelines, The School, Cakehole Presley, Oui Messy, Virgil & The Accelerators, Anterior, OK, Victims Of Convenience, Islet, The Keys, Future Of The Left, Gwenno, Artefact, 5th Spear, Breichiau Hir and Cottonwolf, to name just a few, have kept the unstoppable momentum going. Huw Stephens enabled them all, and he's even more important following the Welsh government's decision in 2014 to stop funding the Welsh Music Foundation.

Shakin' Stevens (born 1948)

Another Cardiffian with his finger on the public pulse who sussed out how to build, and retain, a broad, adoring fan base. Michael Barratt from Ely paid his dues with his band the Sunsets, gigging continually to master the craft of the rock 'n' roll vocalist. Armed with his new name, he was into his thirties before his big breakthrough hit 'This Ole House' in 1981. He went on to be the highest-selling performer of the 1980s, poppy enough to grab the *Smash Hits* generation and retro enough to bag dads nostalgic for their 1950s seat-slashing heyday. Shaky, with more Number 1 hits than any other Welsh act, is now an institution: the Welsh Elvis – an entertainer to the tips of his white daps.

Alec Templeton (1909–1963)

A blind jazz pianist from St Fagans who found fame in 1940s America with unique classical music skits replete with advanced sound effects.

Moira Thomas (born 1962)

Dozens of energetic punk bands emerged in Cardiff in the late 1970s, the many excluded and marginalised latching onto the 'no future' message in the gob-splattered mosh-pits of venues like Montmerence, the Great Western, the Lions Den, the Stowaway, Bakers Row and Grannies. Moira & The Mice, formed by Thomas in 1979 with fellow Cardiffian Rob Brazier, had the biggest local following with their barnstorming original songs before they split after a valedictory Top Rank gig in 1982. They were one of the first Cardiff bands to set up their own label, Rodent Records.

Dave Tidball (born 1957)

Jazz saxophonist and clarinettist who settled in California to become a formidable exponent of 'West Coast cool', exemplified by his tender 2012 composition 'Glamorgan' for the FivePlay Jazz Quintet.

Ceri Torjussen (born 1976)

With interests ranging far and wide from choral to Gamelan, Afro-Cuban percussion to orchestral, funk to poetry, the Welsh-speaker from Rhiwbina has scored full-length Hollywood feature films such as *I, Robot* and *Terminator 3*.

Albert Ward (1917–2001) and Les Ward (1921–2004)

In the 1940s the Ward brothers were harbingers of skiffle, playing bicycle pumps, washboards and anything that came to hand to accompany their country and western songs.

Blue Weaver (born 1947)

Amen Corner's keyboard player thrived after the band split, having stints with folk-rockers The Strawbs, glam-rockers Mott The Hoople and hit factory The Bee Gees before evolving into a Mellotron and synthesizer wizard and in-demand session musician. An ex-Amen Corner member vitally important in Cardiff today is sax player Allan Jones from Swansea, owner of excellent live music venue the Globe in Roath, which opened in an old cinema in 2008.

Gareth Williams (1953–2001)

Bassist and keyboardist with intense, proto-punk experimental trio This Heat in the 1970s, Williams rejected the music industry to study dance and religion in India, where he co-wrote the first *Rough Guide to India*. He was making innovative music again when cut down by cancer.

Jed Williams (1952–2003)

Jazz drummer who overcame countless obstacles in 1984 to establish Brecon Jazz as one of Europe's finest festivals and a landmark Welsh event. The astute, humorous Williams didn't live long enough to see the Arts Council of Wales withdraw funding in 2012 from the Welsh Jazz Society, founded with Cardiff trumpeter Chris Hodgkins in 1978. A fundamental lifeline for Welsh musicians was cut for the sake of £50,000 per annum – a figure that barely covers the expenses of the cabal of subsidy-drunk elitists and craven populists. Jed would have appreciated that polyrhythmic riff.

National Museum &
Gallery Cathays Park

A national gallery is an institution no self-respecting nation would contemplate being without. Edinburgh alone has five such galleries to show the breadth of Scottish art, whereas Cardiff, until recently, had none. A tentative start on this was made in 2012 when the National Museum extended its pre-existing galleries over the whole first floor, but this can be no substitute for a purpose-built national gallery. Unfortunately, less than 10 per cent of the museum's entire collection of art is on show at any one time – the rest gather cobwebs in the basement or in the storage centre at Nantgarw.

Wales has always had to wait patiently for essential facilities long after they were established everywhere else. The National Museum itself was only granted its charter in 1907 after decades of persistent advocacy led by Liberal MP for Fflint Herbert Lewis (1858–1933). Museum funds were granted annually by the Westminster parliament to all parts of the British Isles except Wales until the Liberal government of David Lloyd George (1863–1945) finally relented. Work started in 1910 but completion was postponed by the First World War, so it was not until 1927 that the first part of the museum opened. The east wing and lecture theatre opened in 1932 and the west wing in 1967.

The fine art collection is today recognised as one of the most important in Europe, and that is largely due to the generosity of wealthy Welsh patrons donating their private collections to the nation. Chief among these were the Williams-Wynn family of Rhiwabon, who gifted the old masters of their aristocratic dilettante ancestor Sir Watkin Williams-Wynn (1749–1789); Cardiffian Ernest Morton Vance (1868–1952), who gave his vast array of rare Welsh pottery and porcelain; Cardiff chartered surveyor Derek Williams (1929–1984), who left the museum his splendid modern art collection; and, most significantly, the Davies sisters of Llandinam in Powys. Gwendoline (1882–1951) and Margaret (1884–1963) were granddaughters of Welsh icon David Davies (1818–1890), 'Davies the Ocean', builder of Barry Docks. The strictly Nonconformist sisters together bequeathed 260 works to the museum, and many of these are today the star attractions which draw visitors up the broad

steps and through the Doric columns to view a collection of French impressionist and post-impressionist works of international standing.

Highlights include:

Eugène Carrière (1849–1906): Six paintings of hazy dignity in the symbolist's brown monochrome palette. Conversely, his view of Cardiff docks hangs in the Musée d'Orsay in Paris.

Paul Cézanne (1839–1906): The master who was the bridge between impressionism and cubism has three works in Cardiff, including *Midday L'Estaque*, a sublime roam down dusty Provençal lanes.

Honoré Daumier (1808–1879): Ten works by the prodigious pioneer of naturalism, including one of his celebrated twenty-nine Don Quixote paintings.

Vincent Van Gogh (1853–1890): *Rain at Auvers* was painted shortly before the Dutch genius shot himself in those very fields.

Édouard Manet (1832–1883): Three of the pivotal impressionist's paintings, auguring the birth of modernism, are on display.

Claude Monet (1840–1926): There are three different *Waterlilies* and one of the Rouen Cathedral series among the museum's nine dazzling Monets.

Jean-François Millet (1814–1875): *The Faggot-Gatherers* and *The Sower* are among nine pictures by the leading naturalist-realist.

Camille Pissarro (1831–1903): The 'father of French impressionism' is represented by two paintings.

A Gwendoline Davies bequest to the National Museum: *San Giorgio Maggiore at Dusk* by Claude Monet (1908). (Beyeler Foundation/National Museum of Wales)

Pierre-Auguste Renoir (1841–1919): Perhaps the most famed painting in the museum is *La Parisienne*, the 'blue lady' shown in the very first impressionist exhibition in Paris in 1874, one of three Renoirs held.

The museum also has some major classical paintings, notably *The Funeral of Phocion* by Nicolas Poussin (1594–1665) and *Calm* by Jan Van de Cappelle (1624–1679), as well as old masters plus many important works from the surrealist, abstract, neo-romantic, expressionist and figurative movements. In 2009 £1.4 million was spent acquiring a Pablo Picasso (1881–1973) oil painting, *Nature Morte Au Poron*, to boost the modern art collection in Gallery One. It is very strong on sculpture – there are ten works by Auguste Rodin (1840–1917) alone, including *The Kiss*, which Cardiffians have been ogling since it was given pride of place in the domed entrance hall when the museum opened. These are the big-hitters, shifting postcards and prints in the shop.

Ivor Novello

For decades Cardiff's civic leaders deemed Ivor Novello was worth only a small blue plaque on the house in Cowbridge Road East where he was born in 1893. It was left to the people of Cardiff to fundraise for fifteen years to scrape together the money needed for a long-awaited statue outside the Wales Millennium Centre, a figurative bronze by Welsh sculptor Peter Nicholas (1934–2015) unveiled in 2009. In a city that has named whole blocks of streets after every bastard child of any aristocrat who grabbed land here, it seems extraordinary that recognition of the most famous man ever to come out of Cardiff has been so grudging.

Even by today's celebrity-congested standards, Ivor was a superstar. Composer, film and stage actor, playwright, and the idol of millions worldwide for over thirty-five years, he always seemed to have an unerring nose for what the masses wanted. His musical gifts came via his beloved mam, Clara Novello Davies (1861–1943), director of the Welsh Ladies Choir and celebrated vocal coach. His solidly bourgeois family had moved round the corner to Cathedral Road by the time the boy soprano was packed off to study at Magdalen Choir School, Oxford, and by 1910 his taxman father's work took them to London. Changing his name from David Davies to Ivor Novello, the better to evoke Italian romance, he took a flat in Aldwych above the Strand Theatre in 1913, a London address he would keep until his death.

Narcissistic yet self-effacing, lowbrow yet quick-witted, gentle and generous yet industrious and ambitious, Ivor's big breakthrough came in 1914 when he wrote 'Keep the Home Fires Burning', the song that became the wrenchingly optimistic soundtrack to the First World War. Meanwhile his natural exuberance and guilelessness meant he was gladly gay long before there was any such thing as 'coming out'. He lived openly with his lifelong partner, bit-part actor Bobby Andrews (1895–1976), whom he met in 1916, and he was soon at the hub of the era-defining circle that largely constructed the

Ivor Novello statue, Cardiff Bay.
(FruitMonkey)

pre-liberation image of gay men. Along with his pals Cecil Beaton (1904–1980), Noel Coward (1899–1973), John Gielgud (1904–2000), Somerset Maugham (1874–1965) and Siegfried Sassoon (1886–1967), he embedded the stereotypical association of gay men with glamour and glitz in the public consciousness. Like many in the rich elite and the aristocracy during the interwar period, the flighty, fundamentally shallow man dabbled with fascism, appearing with Coward at a fundraiser for Oswald Mosley's (1896–1980) British Union of Fascists in 1925 – a stain on his reputation he was understandably at pains to conceal later in life.

Fame established early, Novello's stunning good looks came into play in a fifteen-year career as a movie star that began in 1920. Legions of female fans on both sides of the Atlantic swooned at his soulful eyes and pouting self-regard through the 1920s in silent screen box-office smashes *The Rat*, *The Lodger*, *Downhill*, *The Vortex* and *The Constant Nymph*. At the same time his parallel career in the theatre was flourishing, and his biggest successes were still to come.

His first love was the musical, where he could combine all his talents: romantic lead, songwriter, actor-manager, playwright, and tasteful dispenser of high camp to the hoi-polloi. His extravaganzas at Drury Lane through the 1930s, with their multiple scene changes and huge casts of extras and dancers, broke all West End records. Pure escapist candyfloss, *Glamorous Night*, *Careless Rapture* and the rest were the ideal opiate in the 'low, dishonest decade'.

War came again. Ivor was living with Bobby in their dream home, 'Redroofs' in Berkshire, and wrote another massive wartime hit, 'We'll Gather Lilacs', to capture

the fragile hopes of the time. Then it all started to go wrong. His mam, the love of his life, died in 1943 and in 1944 a notoriously homophobic judge jailed him for a month after he was unwittingly talked into a minor breach of petrol-rationing rules by an infatuated fan. Ivor was never quite the same again – one night in Wormwood Scrubs was one too many for the pampered Riverside boy.

His popularity didn't wane after the war as his core audience of middle-aged ladies simply grew old with him. But in 1951, after playing the lead in his delirious operetta *King's Rhapsody*, he dropped dead of a massive heart attack in his flat above the Strand Theatre. His legacy lived on though: when Bobby died 'Redroofs' became a theatre school; in 1955 the Novello Awards were inaugurated and they remain the songwriters' Oscars to this day, universally known as 'the Ivors'; and in 2005 the Strand Theatre was renamed the Novello Theatre, making Ivor one of only four people deemed big enough to have a theatre named after them in 'theatreland'. And now, at last, lingering snobbery and bigotry have entirely faded and there is belated appreciation even in his home town for the multi-talented Renaissance man who, for so many, could 'turn the dark cloud inside out'.

O

Orielau (Galleries)

Aside from the National Gallery (*see* under 'N') a multitude of resourceful practitioners, collectives and entrepreneurs are ensuring that Cardiff today has more art on show than ever before:

Albany Gallery, Albany Road
The oldest privately owned commercial gallery in Cardiff (only Swansea's Attic Gallery is older in Wales) was founded in 1965 by Mary Yapp and portrait painter David Griffiths. Yapp is still the proprietor today as she approaches the age of ninety; the éminence *grise* of Cardiff's visual arts establishment, steeped in the skills of gallery running (her grandfather founded the Glyn-y-Weddw gallery near Pwllheli in 1910) and with a peerless record of championing contemporary Welsh art and new Welsh artists. The Albany's annual Summer Exhibition is a Cardiff highlight for art lovers where the cream of Welsh art – past, present and future – is on display for six weeks.

Arcade Cardiff, Queens Arcade
'Pop-up' contemporary art in vacant shopping units: a constructive response to the massive overprovision of retail space in the city centre.

Arteas Art Café, Cowbridge Road East
Serious Welsh art (plus simple Welsh food) in Canton.

Bayart, Bute Street
Opened in 2002, this gallery is among the best of a growing number of small 'grass roots' spaces in the city. There are a number of exhibitions each year, with the emphasis on contemporary painting and drawing, as well as sixteen small studios on the upper floors occupied by the Butetown artists collective.

Boundary Art, Havannah Street
This is a peaceful oasis of contemplation and aesthetic appreciation.

Bluetown History & Arts Centre, Bute Street
An important project, started in 1987, that logs, archives, collects, publishes and exhibits all aspects of the social and cultural history of the docks. Fascinating exhibitions are held in their evocative Dock Chambers HQ. It was the first purpose-built office in Cardiff's docklands, a mock-Jacobean showpiece by Bute Estate architect Alexander Roos (*c.* 1810–1881) opened in 1860 to dominate the sea end of the Bute West Dock.

Cardiff Met University, Western Avenue
The Cardiff School of Art has been a vital element in Welsh creative life since its foundation in 1865, when it shared a building in St Mary Street with the Free Library. After periods in the Technical Buildings on Dumfries Place from 1900 and the vacant St John's School on The Friary from 1949, in 1965 the school settled in purpose-built premises where the bombed-out Howardian High School once stood in Howard Gardens. In 1976 it became part of the South Glamorgan Institute of Higher Education, which has gradually evolved into today's Cardiff Metropolitan University. The school has built a global reputation in the visual arts and boasts many significant alumni. Much credit must go to Terry Setch, senior lecturer in painting from 1964 to 2001. His approach, linking present events to the art of the past and encouraging pupils to follow their own path, has created a breeding ground of confident experimenters, unshackled from art's many 'isms' (his own work, huge paintings on ship's canvas incorporating Penarth beach flotsam and jetsam embedded in the pigmented surfaces, has a growing reputation too). In 2014 the School of Art and Design left Howard Gardens for the Uni's Llandaf campus.

Castle Galleries, Mermaid Quay
Part of a chain where art-as-investment reaches its apogee.

Chapter Arts, Market Road
This focal point of experimental, left-field art in Cardiff was founded in 1971 by local artists Christine Kinsey and Bryan Jones and journalist Mik Flood. Frustrated by the lack of facilities in Cardiff and certain that neither the notoriously provincial and middle-brow civic leaders nor the distant, Anglocentric Welsh Office would ever take the initiative, they took action themselves and, after years of fundraising, the old Canton High School buildings were turned into a centre where all the creative disciplines could be housed.

Over four decades later, Chapter is an essential life force in the city, without which Cardiff would scarcely have a contemporary arts scene at all. Here is Cardiff's most essential gallery along with studios and tenant artists in a hive of workspaces. Demanding, hilarious or provocative avant-garde installations are frequently on display and the front of the building has a big 'light box' where works are shown outwards to sceptical Cantonians. Chapter has asserted the vibrancy of the many artistic communities in Wales and thrust them into international contexts with great self-belief.

Craft in the Bay, The Flourish

In a re-erected and refurbished cast-iron-framed warehouse that once stood by the Bute East Dock, glazed on two elevations and attached to a modern extension with a sloping pointed roof, the Makers Guild in Wales organise a programme of exhibitions. Formed in 1984 as a co-operative, the guild has seventy-five members covering every imaginable craft from weaving to woodworking, patchwork to pottery.

Fireworks, Tudor Lane

Ceramic art co-operative begun in 1995 in Roath before moving to Riverside in 1998. Their studios are a lively, creative environment with kilns, welding equipment and spray booths where clays are transformed in surprising ways.

Fountain Fine Art, Morgan Arcade

Commercial gallery opened in 2012 in the 1899 Morgan Arcade.

Futures Gallery, Pierhead Building

Various exhibitions and events are held throughout the year in the Assembly's Cardiff Bay premises. Often more 'Don't Rock the Boat' than 'Wrth Ddŵr a Thân'.

g39, Oxford Street

An adventurous artist-run initiative set up in Mill Lane in 1998 by Anthony Shapland and Chris Brown to give opportunities to unestablished artists and recent graduates from Cardiff School of Art. Since its inception over 300 artists have had their work exhibited, most Welsh or Wales-based. Now in Roath, having been ousted from Mill Lane in 2012, g39 also hold shows in temporary spaces around Cardiff – disused shops, warehouses, billboards, video screens, streets and derelict land.

Gallery/Ten, Windsor Place

A 2014 addition to Cardiff's burgeoning art scene, concentrating on the amazingly diverse riches of contemporary Welsh art.

The Gate, Keppoch Street

Plasnewydd Presbyterian church, with a hall dating from 1886 and chapel from 1901, is one of the great examples of Nonconformist Gothic in Roath. In 2004 it was sympathetically converted into a multi-functional arts centre, retaining features like the intricately patterned iron columns. There are two galleries featuring established artists, group shows and community art projects.

Inkspot, Newport Road

In the basement of a deconsecrated 1897 Methodist church is a gallery exhibiting and selling works by interesting Welsh artists like Richard Oliver, once keyboard player

The Gate Arts Centre, Roath. (Ham)

with now unmentionable band Lost Prophets, and Andrew Lanning, whose family run the arts and crafts store upstairs.

Kooywood Gallery, Museum Place
A commercial gallery holding regular exhibitions of past and present Welsh art, established in 2004 by Rhian Kooy. Recent fascinating exhibitors include Pontcanna's Bev Howe (hyper-real oils of lone women staring moodily into the distance) and Ebbw Vale's Phil Parry (dramatic renderings of the Welsh coastscape).

Llanover Hall Arts Centre, Romilly Road
Named in honour of Lady Llanofer (1802–1896), bardic name Gwenynen Gwent (the Bee of Gwent), a ceaseless advocate for Welsh language and culture when few others were, this is a buzzing council-operated community centre with a gallery, where local artists, children, students putting a portfolio together and amateurs attending the various evening classes and summer schools are supported and encouraged. The inspiration behind Llanover Hall since his arrival as first artist in residence in 1979 was Tony Goble (1943–2007) from Newtown in Powys. He was on the staff here right

up to his death and his benign, bearded presence is much missed, while his own work, often featuring mythological Celtic beasts wearing the artist's puzzled face in skewed modern Cardiff settings, is itself beginning to draw posthumous praise. Goble led many a campaign over the years to save Llanover Hall from closure; his successors will have to pick up the baton of his vigilance and idealism in readiness for the next time the council try to shut this special Cardiff place.

M.A.D.E., Lochaber Street
Opened in 2009 as Milkwood before a renaming in 2013, M.A.D.E. is home from home for Roath's self-conscious and self-important hipsters. The inventive creativity on display is marred by too much jargon about 'accessibility' and 'community'.

Martin Tinney Gallery, St Andrew's Crescent
The leading private commercial gallery in Wales was established in 1989 and moved from West Wharf to a mid-Victorian townhouse with three floors of exhibition space in 2002. The smart but not snooty galleries show paintings by all the leading marketable twentieth-century Welsh artists, as well as the best of the younger generation.

Norwegian Church Arts Centre, Harbour Drive
Built in 1868 alongside the West Dock, deconsecrated in 1974, dismantled in 1987 and then re-erected on the waterfront in 1992, the white clapper-board cornerstone of Cardiff Bay holds occasional exhibitions in the tranquil upstairs gallery.

National History Museum, St Fagans
A £25 million redevelopment called 'Making History' is underway at St Fagans, in which the main building will be transformed to explore the meaning of being Welsh through objects, photographs, art, film and personal stories. As Welsh identity must be consciously adopted as an act of defiance and self-exploration, the new facility will help prompt the navel-gazing that generates art.

Off the Wall, Cardiff Road
A commercial gallery opened in 2010 in the superb 1863 Probate Registry building of John Prichard (1817–1886) at Llandaf. The fact that the website misspells the name of John Prichard, himself one of Wales' greatest artists, says it all.

Oriel Canfas, Glamorgan Street
Founded as a cooperative in 1998, Canfas exhibit intriguing contemporary art in Canton.

Print Market Project, Market Road
A print studio complex, founded in 2011 by woodcut artist Pete Williams in remnant buildings of the old Canton Cattle Market.

Third Floor Gallery, Bute Street
A gallery concentrating on documentary photography, opened by photographers Joni Karanca and Maciej Dakowicz in 2010.

Trace, Moira Place
Events and exhibitions take place periodically in the backstreet Adamsdown home of André Stitt, a Belfast-born performance artist who is director of the 'Time-Based' art course at Cardiff School of Art. Trace opened in 2000 and has since hosted a series of performance, installation, sonic and interactive events which uncompromisingly debunk artifice with mind-expanding intellectual reach.

Vellindre Hospital, Velindre Road
The South Wales Art Society, formed in 1887, holds a permanent rolling exhibition of its members' work in the corridors and dining room of this cancer hospital in Whitchurch. Some of the Welsh paintings acquired by the Contemporary Art Society of Wales since it was formed in 1937 can also be seen at Velindre.

Victoria Fearn Gallery, Heol y Deri
Silversmith Fearn's commercial gallery in Rhiwbina specialises in jewellery, sculpture, ceramics and glass.

Wales Millennium Centre, Bute Place
There are two gallery areas above the Glanfa foyer concentrating on contemporary Welsh and Wales-based artists. Jonathan Adams' building is itself a work of visual art that provokes strong reactions. Andrew Vicari likened it to a 'beer barrel', the *RIBA Journal* damned it as 'painfully fussy' and 'killing off acres of space', while the *Western Mail* reckons Cardiffians affectionately call it 'the armadillo' (they do not). My main concern is what a few decades of Severn drizzle will do to those rivets and planks.

West Wharf Gallery, West Canal Wharf
There's always something absorbing to see on the top floor of Jacobs Antiques Market.

P

Parc Cefn Onn

This wonderful and eerie country park, acquired by Cardiff Council in 1944, was originally created in 1918 by Cardiffian Ernest Prosser (1867–1933), chairman of the Rhymney Railway. Attempting to make a therapeutic retreat for his invalid son, he dammed the Nant Fawr's gurgling tributaries to form exercise ponds – but after the boy died of tuberculosis in 1926 Prosser lost enthusiasm for the project. Cardiff was the ultimate beneficiary: hidden within the magnificent forest of giant evergreens and acid-loving azaleas, camellias, magnolias and rhododendrons, the chain of intact ponds seethes with life.

Pen-Y-Lan

Across Cardiff's boundary with Newport on the old main road is the village of Castleton (Cas-bach). The castle after which it was named was originally Castell Gwynllŵg, a sixth-century dwelling of Gwynlliw Farfog (c. 480–523), King of Gwynllŵg (Wentloog). Converted into a domineering motte by the Normans in the twelfth century after the conquest of Gwent, it was abandoned by the fifteenth century and today is an unexcavated, tree-covered mound in a private garden off Mill Lane. Via narrow Coal Pit Lane and over the A48(M) and M4 bridges is Pen-y-lan Road, a dead-straight remnant of the Roman road between Caerleon and Cardiff. Up at Pen-y-lan ('the hill top': like all Welsh topographical names, spot on), there is a complete panorama of Cardiff from the east, its tentacles sprawling to the far western horizon.

Queen Street

Despite the clashing architecture and scrum of stalls, carousels, street vendors and buskers, the half-mile length of Queen Street is nevertheless one of the great walks of Wales, with an urban sense of enclosure counterbalanced by generous breadth (a legacy of the long front gardens of the cottages of eighteenth-century Crockherbtown). Such a walk is best started from the east end at Queen Street Station, treading the route followed since the opening of the Taff Vale Railway in 1841 by six generations of people from the valleys arriving in the metropolis, and maximising the impact of Cardiff Castle as the gentle bends of the old highway across southern Wales gradually unveil the spectacle ahead.

The eastern end of Queen Street. (welshleprechaun)

Q

Few buildings of historic or architectural merit are left in Queen Street. The functional requirements of two continuous lines of shops proved incompatible with the small scale, high-quality materials and decorative embellishments of all the Georgian and most of the Victorian structures. But there are some notable Victorian survivors and a few exceptional twentieth-century works. The first block on the north side (currently Sainsbury's, KFC and Starbucks), is graceful white art deco from 1929 that curves with the street line, drawing you forward. It was built on the site of the last domestic dwellings in Queen Street, demolished in 1925. Adjacent is the superior Portland stone Barclays Bank of 1945 (now Poundland) continues the curve and elevation to the corner of Windsor Place. Facing them across the road is the 1990 Capitol shopping centre (note, Capitol not Capital – it was named after the cinema that stood here from 1921 to 1983, one of six lost Queen Street cinemas), looking like a mediocre multi-storey car park. Upstaged by the vast St David's centre, this former hotspot of chic consumerism has become shabby and sidelined.

After the 1980s block between Windsor Place and Park Lane is the monumental 1884 Park Hotel (now Jurys Inn), a Renaissance-style mass stretching all the way to Park Place with grandstanding stonework and a pavilion roof. It was built on top of the 1839 Dock Feeder, which still runs beneath its eastern end. Along Churchill Way opposite, under which the Feeder was buried in 1949, there are ten pairs of Victorian villas on the west side. Largely ruined by inappropriate windows, doors, steps, extensions and commercial car parks to the rear, these archetypal gothic revival houses contrast starkly in size and style with the overweening price-crash apartment blocks on the east side of the road – and make them shrivel in comparison.

Back in Queen Street, the muted mudstones of the 1900 Royal Chambers maintain the grandiosity on the Park Place corner and WHSmith next door is a riot of carved white stone including human heads atop ornate bay windows. Dating from 1885, it became the Seccombes department store in 1891. Seccombes, acquiring neighbouring buildings to compete with St Mary Street rivals Morgans and Howells, crept up Park Place and along Queen Street before closing in 1977. One legacy is its modernist westward extension (now Holland & Barrett and part vacant), a jarring but effective 1930s intrusion which could look more attractive if it were cleaned. On the south side between Churchill Way and Charles Street the National Provincial Bank (now NatWest) of 1892 retains the original ground floor façade on the Churchill Way corner and Johnsons Chambers (Burger King) on the Charles Street corner is also from the 1890s, but in between some mean 1960s units and the dull Littlewoods store of 1938 (closed 1998, now Next) make for an untidy stretch.

From Charles Street the south side is taken by a 1930s Marks & Spencer, hidden behind a malign glass and steel appendage of 2008, and then a lucky survivor from the 1880s (Samsung) before the St David's centre first phase of 1982 begins at what was the corner of lost Paradise Place. Regular facelifts have failed to cloak the unattractive design. Next door is a red-brick and Bath stone essay from 1901 (M & Co) topped with curly pediments and urns.

Looking east down Queen Street and across to Queens Chambers, centre. (welshleprechaun)

The Clock Tower of the castle now comes into sight as the north side continues past a section which once included the 1899 Empire Music Hall (later the Gaumont cinema, demolished in 1962 – currently the massive glass wall of HMV and JD Sports is on the site), then three recent efforts which make no concession to aesthetics (Ann Summers, Nationwide, Matalan), before reaching three consecutive plums: the early modernist 1921 Dominions House with its plangent Dominions Arcade, the elaborate 1898 Lloyds Bank and then the expansively sumptuous 1914 Principality Buildings on the corner of The Friary.

The Principality Building Society, founded in 1860 in Cardiff, is the largest independent financial business in Wales. Its extensions to the rear in the 1950s became possible after the Glamorganshire Canal was filled in and The Friary was widened alongside its course (Greyfriars Road was created between Park Place and The Friary at the same time). The St David's centre has consumed most of the other side of the road up to the point where the canal ran under Queen Street in a tunnel. Of note here are the brilliant Midland Bank of 1919, one tall storey between Ionic columns, the 1960s BHS (now Primark) next door, and the dragon mural on the façade of Boots. This building went up in 1961 as a prestige development associated with a big name store – Allders, hyped as Cardiff's saviour then much as John Lewis is now. The early Victorian Tunnel Court and the urbane Tivoli pub (originally the

eighteenth-century Crosskeys) were lost in the process. The shared, slowly unfolding world of the public house has been deemed anathema to the instant gratification mind frame required to fill shops, so Queen Street, uniquely for the main street of a UK city, doesn't have a single pub anymore.

With the castle battlements materialising ahead, Queen Street saves its best for last. After the 1994 Queens Arcade, part of the expansion of the St David's centre that has effectively privatised most of Cardiff's city centre, comes the fabulous 1870 Venetian Gothic Queens Chambers by local architect Charles Bernard (c. 1835–1918) – once the entrance to the original 1875 Queens Arcade that dog-legged to Working Street. Despite being almost permanently to let, this sensuous apparition completely eclipses everything in the vicinity; a daring statement of Cardiff's place in the European tradition that was never really followed through in the rest of the town.

The south side is completed with a flurry of four varied buildings whose long, narrow dimensions match the ancient pattern of the medieval burgage plots. Over on the north side the Queenswest shopping mall, which opened in 1987, has dropped the mall idea and now just houses big chains (Superdrug, Burton, and Waitrose). The block was originally built in 1955, replacing the bombed Carlton Hotel. Beside it is a heavyweight neoclassical showstopper (another Poundland) which was built for Marments department store in 1929 when their 1879 shop in Duke Street was demolished in the process of clearing buildings from the front of the castle. Marments, the most fashionable store in Cardiff in its heyday, closed in 1986. Queen Street ends with some nondescript 1980s and 1990s units to the Kingsway corner, where the Red Lion pub and Evan Roberts's department store once dominated. To the rear, in an unnamed service lane off Kingsway, is the last fragment of the twelfth-century town wall: running one's hands over the ancient river cobbles and the patchwork repairs is an intense experience.

So, at the Queen Street–Kingsway–Duke Street–St John Street crossroads, one arrives at the heart of Wales, the axis of the 'T'-shape of ancient Cardiff. Appropriately, here is a statue of a Welshman with a big heart: Nye Bevan (1897–1960) from Tredegar, architect of the National Health Service. The 1987 bronze by Robert Thomas (1926–1999) is one of four works in Queen Street by the Cwmparc-born sculptor. Nye appears in characteristic pose, leaning forward, looking westward, urging the people to rally behind the socialist cause, and on to the next struggle.

Roath Park Lake

A leisurely promenade around the 1.5-mile circumference of this most famed of Cardiff's lakes has been an uplifting social ritual for Cardiffians on high days and holidays since Roath Park first opened in 1894. The 12 hectare (30 acre) lake was a Bute estate scheme that involved the damming of the Nant Fawr at Coed Mawr and flooding the lush, squelchy watermeadows of Cefn Coed, Y Celyn, Derwen Deg and Y Wedal Isaf farms. The lake takes up a third of the dog-leg park and has five substantial islands at its north end, crowded with water birds, while the south end features the 1915 Scott Memorial lighthouse, a promenade along the top of the dam and tumbling stepped cataracts of overflow water which takes the Nant Fawr onward to its confluence with the Rhymni. Because it is an unnatural imposition, the lake has turned out to be problematic and high maintenance; it is bedevilled by toxic algal blooms that mean swimming is banned, and requiring regular dredging to stop it reverting back to the bogland it secretly longs to be.

Rugby League's Holy Trinity

After the great rugby schism of 1895, when the Northern Union (NU) broke away from England's Rugby Football Union (RFU) over the issue of payments and created rugby league, the NU assumed solidly working-class Wales would embrace the new professional game as keenly as Yorkshire and Lancashire. They were wrong. Yes, Welsh miners and steelworkers could not afford to play without being compensated for lost earnings; but it was not a pressing problem, since they were being paid, whether in 'boot money', brown envelopes, backhanders or favours. Coal was at its zenith and the Welsh economy was awash with ready money to stuff into players' pockets. The Welsh Rugby Union (WRU), founded in 1881, had a fifteen-year head start on league, and it was going to take more than cash carrots to wean players away. Schism was avoided in Wales and after victory over the All Blacks in 1905 the fifteen-man game became synonymous with Welsh identity in a way that league could not hope to match.

That didn't stop the NU trying again though – they needed their game to spread to give it international standing. It was developing in Australia and New Zealand, but nowhere else. A Welsh NU was formed in 1907 and clubs were grafted onto Aberdare, Barry, Ebbw Vale, Merthyr, Mid-Rhondda and Treherbert. But by 1912 all had folded and the NU retreated back to its core constituency.

In 1922 the NU became the Rugby Football League (RFL) and organised another attempt to convert Wales. Economic depression was hitting hard; it was an opportunity for the RFL to expose the hypocrisy and class-divisions inherent in union's 'shamateurism'. They handled it all wrong by trying to lure individual union clubs to league, and were again rebuffed. But players in unemployment-racked Wales started to be tempted by league's wages; league scouts increasingly made offers poor Welsh boys could not refuse.

It began as a trickle and was soon a tidal wave. 400 Welsh players 'went north' between the wars alone, including seventy internationals. They did so despite the WRU's malevolent reaction: lifetime bans were dished out to anyone who even played a friendly match under league rules, effectively exiling them from Wales. After the Second World War, the pattern continued. The RFL made another attempt to stimulate a Welsh competition between 1949 and 1955 before that too was abandoned due to lack of interest and finance. Through the 1960s and 1970s league didn't stand a chance in Wales: union had Gareth, Barry, JPR et al; league had Eddie 'up and under' Waring (1910–1986) in a cloth cap at Featherstone Rovers on Saturday afternoon telly. However, the only country where union was a working-class game remained particularly vulnerable to drainage of individual talent. Notable code-switchers included players of the calibre of David Watkins, Maurice Richards and Jonathan Davies, until everything changed in 1995 when union finally turned pro and brought the long years of trench warfare between the two codes to an end.

The ending this of discrimination meant that more games were at amateur level; the seasonal shift of top-level league to summer in the northern hemisphere meant league no longer had to fight the losing battle against soccer and rugby union in the winter; the haemorrhaging of players from Wales came to a complete halt; from henceforth a move from league to union was as likely as vice versa. In 2005 the governing body, the Rugby League International Federation (RLIF), granted Wales Rugby League (WRL) full sovereign status, and in 2008 WRL was elevated to full membership of the RLIF, a very rare example of Wales freely joining the intercourse of nations.

With hindsight, the remarkable relocation of huge numbers of Welshmen and their families to northern England over almost seventy years can be seen as the biggest sporting migration ever, confirmation of the central position of sport in Welsh affairs, and the first manifestation of today's globalised sporting market of mercenaries for hire, criss-crossing the planet selling their prowess.

Wales' loss was rugby league's gain, because it was players poached from Wales, three of them in particular, who established league as a popular spectacle, who built clubs that would become superpowers and who defined and personified the style and

tactics of the thirteen-man game. And, by showing how brilliant the Welsh can be at the game, it was the trailblazing 'holy trinity' who ultimately paved the way for rugby league's exciting prospects in modern Wales. All were Cardiffians:

Jim Sullivan (1903–1977)

No player was missed by Welsh rugby union more than league's first great Welsh capture, Jim Sullivan from Elaine Street (demolished 1972) in Splott. The precociously talented full-back, a Cardiff RFC regular by the age of sixteen, signed for Wigan in 1921 and, across thirty-five years as player and coach, he was the key factor in the club's growth into the most successful club in the history of English rugby league – a standing maintained by today's Wigan Warriors (renamed in 1997 following the 1996 formation of the Super League). As a player he set rugby league all-time records for most appearances (928), goals (2,867) and goals in a match (twenty-two) that still stand and are unlikely ever to be beaten, and he also still holds Wigan's total career points record (4,883). The immense kicking power he perfected in his youth on the East Moors and at the Arms Park, thrown away by Wales, was the making of Wigan. His post-playing career as a coach was equally significant: after six successful seasons coaching Wigan he went on to further glory at St Helens, guiding them to two Championships and their first ever Challenge Cup victory in 1956 – breakthroughs that helped transform a second Lancashire club into Super League behemoths.

Jim Sullivan, 1930. (Rugby League History)

Gus Risman (1911–1994)

Another Cardiffian to slip out of union's grasp and become a league legend was this powerful, intelligent centre who signed for Salford as a seventeen-year-old in 1929. Through the 1930s the boy from Butetown was the catalyst who forged Salford into invincibles, laying the foundations of today's Super League stalwarts. In addition he was instrumental in popularising the game in France where Salford's missionary trips gave league its first bridgehead in continental Europe. Super-fit Gus played the tough sport for an incredible twenty-five years, scoring 3,825 points in 791 games, and his long career culminated in a remarkable swansong as player–coach with newly formed Workington Town. He led the Cumbrian minnows to the Championship in 1951 and, at the age of forty-one, the Challenge Cup in 1952 – he remains the oldest competitor to appear in a Challenge Cup final to this day. No other club has ever won both trophies so soon after being founded and Workington are still punching above their weight at level 2 in the league pyramid.

Billy Boston (born 1934)

A product of the Tiger Bay melting-pot who went to the same South Church Street School (demolished 1969) that Risman had attended, Billy Boston is perhaps the best-known rugby league player of all time. He played union for Neath before Wigan lured him away in 1953 and during fifteen seasons in the cherry white hoops the winger's strength, speed and hand-off brought him an astonishing 478 tries (still the Wigan record) in 488 appearances. After retirement he ran the Griffin pub close by Wigan's Central Park ground, and his amiable, easy-going nature turned it into a rugby league shrine. When Wigan left Central Park in 1999 to ground share at Wigan Athletic FC's new stadium (currently sponsored as the DW Stadium), the East Stand was named the Boston Stand in Billy's honour.

Scott of the Antarctic

Cardiff makes much of a tenuous connection to Captain Robert Falcon Scott (1868–1912). Most recently, on the 100th anniversary of the disastrous conclusion to Scott's Antarctic expedition, in which he and his four companions died, the National Museum of Wales held a four-month-long exhibition dedicated to his exploits – an honour bestowed on nobody else from outside the arts and the sciences in the museum's ninety-year history.

What connection there is was the contrivance of Cardiff's notoriously calculating shipowners and coal barons. Ever alert to opportunities for publicity and personal advancement, they muscled in on Scott's epic journey even before it started by promising to fill the coal bunkers of his ship, the *Terra Nova*, for free if he sailed from what was then the world's busiest coal port. The marketing ploy worked, and on 15 June 1910 the *Terra Nova* departed from Roath Basin for Cape Town (Scott went back to London to do more fund-raising, joining the expedition later in South Africa). Solely because of the pretty minor and mundane fact that he stopped a while to fill up with fuel, Cardiff has been fetishising Scott ever since.

After the *Terra Nova* limped back into port from the calamitous venture in 1913, Cardiff was hitching itself to Scott in no time, erecting the 'Scott Memorial' lighthouse on Roath Park Lake in 1915 and installing a memorial tablet in the City Hall in 1916. You might think that would be enough memorials for what was, after all, a complete failure. But far from it; 100 years on Cardiff is awash with reminders of the stubborn amateur.

There's a mini-neighbourhood named after him (Scott Harbour: gated apartment blocks and offices built around what was a linking canal between Roath Basin and East Dock); numerous streets and buildings and two current pubs (the Discovery and the Terra Nova) name-check Scott associations; there's a 'Scott Room' and a blue plaque at the Royal Hotel where the expedition members ate dinner before they headed south; the Captain Scott Society was founded in Cardiff in 1982 and still holds its meetings in the city; the binnacle (a special compass) of the *Terra Nova* is housed in the Pierhead Building; a granite and bronze floor mosaic, Compass Rose by Sebastien Boyesen, was installed at Scott Harbour in 1997; and, just in case saturation

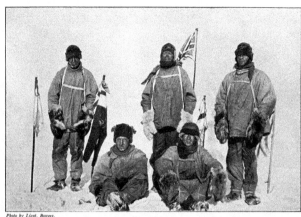

Scott and his men at the
South Pole, 1911.

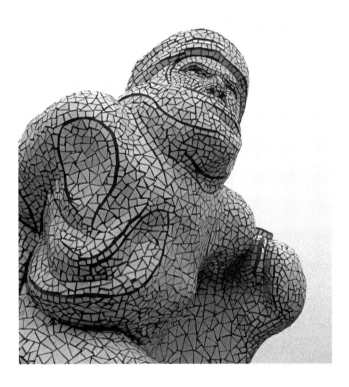

Scott Memorial, Cardiff Bay.
(Tony Hisgett)

point had not yet been reached, in 2003 the 'Scott Antarctic Memorial', Antarctic 100 by Jonathon Williams, appeared on the waterfront at Cardiff Bay.

Why this obsession? Scott's home town (Plymouth), the home towns of the other deceased men (London, Cheltenham, Greenock and Rhosili), the expedition's base in New Zealand (Christchurch), their last port of call before Antarctica (Dunedin), the headquarters of the Scott Polar Research Institute (Cambridge), the hut on Ross Island, the locations of their deaths on the Ross Ice Shelf, and indeed the South Pole

itself ... all have valid reasons to make much of their Scott links – but Cardiff's small role hardly calls for such excessive over-egging.

Scott was absolutely clear about the purpose of his 'Race to the Pole' against Norwegian Roald Amundsen (1872–1928): 'to secure for the British Empire the honour of this achievement'. Scientific enquiries came a distant second to imperialist swaggering. Ultimately, partly due to sloppy preparations, partly due to an overestimation of his own abilities, and partly due to unusually dreadful weather, Scott was beaten to the South Pole by Amundsen. With Edward Wilson (1872–1912), Lawrence 'Titus' Oates (1880–1912), Henry Bowers (1883–1912) and Welshman Edgar Evans (1876–1912) he got there on 17 January 1912, thirty-three days after Amundsen's team of five men. Norway, which had only gained independence from Sweden in 1905, basked in the 'honour' and in the pitiless Antarctic winds Scott and his men succumbed one by one on a nightmare trek back to base camp.

Scott's most precious legacy is surely the beautiful, spare, stoical prose of the diary he kept right up to his death, ending in the famous final sentence, 'for God's sake look after our people'. Making that heartfelt plea practical policy is the only lasting memorial to Scott that Cardiff ever really needed.

Second World War

Considering its strategic importance on the vital Atlantic convoy link to North America, Cardiff was spared the worst of German bombing raids compared to other western ports, such as Belfast, Glasgow, Liverpool, Plymouth, Portsmouth and Swansea – largely thanks to a combination of well-marshalled anti-aircraft measures and heroic civil defence efforts. However, the Blitz still destroyed over 600 buildings and damaged 30,000 others right across the city, and killed 355 people and seriously injured another 502 – the biggest loss of life in Cardiff since the cholera epidemic of 1848. This is where the bombs fell:

Bluetown and Spott
The very first Luftwaffe attack on Cardiff came on 22 June 1940 when a lone bomber unloaded over the docks at night, causing slight damage to a ship in the East Dock. The next attack also targeted the docks and this time it was fatal: a bomb detonated in the hold of the tanker *San Felipe* moored in Roath Dock and six seamen died in the fire. Further attacks on the docks continued through 1940, the 'phoney war' period, when Cardiffians began to get used to blackouts, the wailing of air-raid sirens, the low growl of approaching bombers and huddling in back garden Anderson shelters. The worst incident killed five in Tresillian Terrace and Dumballs Road and brought about the demise of Cardiff landmarks the Tresillian Hotel and the Ice Factory & Cold Stores. From 1941 Bute Street, Cardiff's potent and poetic highway to the sea, was repeatedly on the receiving end due to its position alongside railways, factories and docks – and

it never recovered. One time, twenty people died in a series of massive explosions that flattened five buildings between Hannah Street and South Loudoun Place, including salty sailors' taverns the Marquis of Bute and the Loudoun. The many unsightly gaps in what had been a stately promenade of lodgings, pubs, shops and cafés were not filled post-war, so giving the council another excuse to raze the whole of Tiger Bay by 1970.

Despite the docks being the prime target and receiving half of the total 2,000 bombs that were dropped on Cardiff, dock infrastructure got off surprisingly lightly; only Mountstuart Graving Docks and Roath Dock were actually hit, and both were repaired so well it's hard to locate the impact points today. Rapid responses by firefighters dousing incendiaries made sure that night-bombers were bombing blind, and many devices plopped harmlessly into deep water. Factories in Harrowby Lane (now covered by the short-let 'serviced apartments' of Century Wharf) and East Canal Wharf (now Callaghan Square) were burnt to ashes and the giant 1903 Currans engineering works in Hurman Street, which made shell casings as part of the war effort, was often hit but survived. Currans closed in 2005 and gated apartment complexes for buy-to-let investors are the inadequate compensation Cardiff got for 400 lost manufacturing jobs. Big, unmissable targets like the GKN steelworks and Spillers mill on the East Moors were also frequently damaged with sporadic loss of life, but never enough to halt production. It took cost-cutting globalisation to do that: the steelworks, opened in 1891, closed in 1978; the mill, a 1933 tour de force in reinforced concrete by modernist maestro Oscar Faber (1886–1956), was inexplicably demolished in 2002.

Splott's position enclosed by railways meant regular strikes by wayward bombs; houses in Hinton Street and South Park Road, rebuilt post-war in cheaper brick, were taken out in the same raid that seriously hurt the 1891 Moorland Road School and the 1906 University Settlement (St Illtyd's College from 1924). The school lost its Gothic gables, chimneys and towers to become today's flat-roofed box, still bearing the sign for erased Millman Street on its north side, and St Illtyd's eventually had to relocate to Llanrumney in 1964. The stylish 1930s extension of the college was bulldozed in 2016 – however the Old Illtydians retain a Splott presence, having taken over the 1896 Roath Carlyian Club on Splott Bridge in 1985. Eight died when houses and drains in Corise Street, Elaine Street, Enid Street, Swansea Street and Portmanmoor Road were blown up – a minor bruising compared to the council's total extermination of the whole tightly knit lower Splott community in the 1970s. Among the losses was Splott Welfare in Portmanmoor Road, known as the 'Bomb & Dagger' after a scary wartime incident with an incendiary. The forgotten venue subsequently gained unlikely immortality in the work of influential 1980s post-punk band Young Marble Giants.

Canton and Riverside

Nowhere in Cardiff was more decimated than Canton and Riverside, punished for their proximity to the vast marshalling yards of the Canton Depot. On 2 January 1941

Cardiff endured its worst bombardment of the war when, on a freezing night under a full moon, over 100 planes pummelled the city for ten hours. More than sixty died in Riverside in the first half-hour, as a veritable eruption ripped through Blackstone Street, Craddock Street, De Burgh Place, De Burgh Street, Neville Street, Ninian Park Road, South Morgan Street, Wyndham Crescent, Wyndham Place and Wyndham Street. In the 1950s nearly everything was rebuilt, including long sections of terraced housing in De Burgh Street and Neville Street – only betrayed by the inferior post-war materials used. Blackstone Street, the tops of Craddock Street and Wyndham Street and South Morgan Street were not replicated as before; here, blocks of flats and maisonettes usurped the terraces.

At Sophia Gardens the 1857 South Lodge, a whimsical delight by Bute Estate architect Alexander Roos (1810–1881) was completely destroyed, killing five passers-by on Cowbridge Road and punching holes in the City Temple and the Westgate Hotel opposite. Those buildings would be fully repaired, but the stone Lodge was no more and a rather humdrum brick replacement of 1954 has had to suffice. In the years since, 75 per cent of Cardiff's first public park has disappeared under tarmac. In Tudor Street the presses in the neo-Gothic Western Mail print works kept working despite the rest of the building being reduced to its girders (later demolished, it's now the site of a private car park).

Canton was attacked along the length of Cowbridge Road, from City Lodge (originally the huge workhouse, today St David's Hospital), via Canton High School (as a result of this bomb Cardiff acquired brand new Cantonian High in Fairwater in 1962 and Chapter Arts in the old School in 1971), to multi-gabled Lansdowne School (repaired and still open as a primary school). In between, there was widespread destruction of homes and businesses, notably in Albert Street, Ann Street, Avon Street, Glamorgan Street, Gray Street, Harvey Street, Picton Place, Kings Road and Wellington Street. Although much was restored, a lot was only patched up. In the 1960s the ramshackle grid of streets between Cowbridge Road East and Wellington Street was replaced by a council estate that has not aged at all well.

Later major raids on Canton and Riverside hammered Brook Street, Coldstream Terrace and Mark Street (necessitating total demolition and quite different post-war replacements) and culminated horribly in 1943 when five died in four adjacent houses in York Street reduced to rubble. As the last bomber flew off its machine guns took a pop at a train, leaving bullet holes that can be seen today on the parapets of the Sanatorium Road bridge.

City Centre and Cathays

In the eye of the storm, the city centre got a battering from all directions. The wide open spaces of Bute Park and the castle grounds absorbed many explosions, and a sharp eye will notice some of those locations from otherwise illogical depressions in the lawns. Among the bigger buildings hit were Cardiff Arms Park, the Carlton in Queen Street, St David's Cathedral, the Co-operative building in St Mary Street,

the General (now Central) Station, the Corporation Transport HQ in Paradise Place, Peacock's in Queen Street, Bristow Wadleys in Mill Lane and the Noah Rees grain warehouse in Working Street. Random destruction of homes and businesses killed over seventy people, most particularly in Bridge Street, Custom House Street, East Terrace (Churchill Way), Charles Street, Frederick Street, The Hayes, Hills Terrace, Mary Ann Street, Millicent Street, New Street, Tredegar Street, Union Street, Wharton Street and Wood Street. Unlike elsewhere, there were virtually no attempts to repair and renovate except at the 1887 St David's Cathedral and the 1934 station. Instead, post-war councils took the opportunity granted by Hitler to clear the city centre of residential streets, small trades and diversity. For decades the area between Queen Street and Bute Terrace was blighted by planning schemes and left unmaintained to depopulate and decay, a serenely shabby twilight zone of rutted open-air car parks, cracked mortar and tumbledown dives. Social cleansing was duly achieved, and all was eventually covered by today's unsustainable consumerist farrago. Only a stump of Frederick Street is left to remind shoppers that 20,000 people once lived in old Cardiff. Consigned to history were Canal Street, Charlotte Street, Cross Street, David Street, Ebenezer Street, Edward Street, Hills Terrace, Homfray Street, Little Frederick Street, Little Tredegar Street, Little Union Street, New Street, Paradise Place, Plymouth Street, Rodney Street, Ruperra Street, Stanley Street, Tunnel Court and Union Street; while Bridge Street, Love Lane, Mary Ann Street, Millicent Street and Tredegar Street are just leftover access routes. The surviving mid-Victorian town houses in Charles Street give a hint of what was chucked away. While they were at it, the Tory council of the 1940 and 1950s also got rid of the magnificent Glamorganshire Canal and substantial segments of the medieval town wall.

To the north in Cathays the Civic Centre somehow evaded damage thanks to fire wardens literally hurling incendiaries off the roofs of the monumental structures, but three years of bombing brought appalling scenes to Cathays Terrace, Catherine Street, Coburn Street, Llanbleddian Gardens, Woodville Road and Wyeverne Road. In Cathays Terrace, where eighteen died in one raid, the entire block south of Catherine Street was wiped out, including the 1887 St Teilo's Mission Hall, as well as five adjacent houses on the May Street corner – late twentieth-century housing makes these sites stand out clearly today. Similarly, in Wyeverne Road, where twenty-three died when fifteen consecutive houses and the 1897 Public Hall were destroyed by high explosives, the modern replacements, including the Dar Ul-Isra mosque on the Hall site, are glaringly conspicuous. In Allensbank Road a scene out of a horror film was enacted after Cathays Cemetery was bludgeoned by bombs that sent headstones and corpses hurling far and wide; the local dogs were soon on the streets, gnawing the skulls of the Cardiff dead. Nobody in Cathays could have guessed at the height of the Blitz that this resilient, archetypical Cardiff community would have evaporated into thin air seventh-five years later, scattered to the four winds while Cathays was turned into a colossal campus where a staggering 66 per cent of the total population are transient students.

Grangetown

In the January 1941 raid sixty-five died in Grangetown alone, vulnerable due to its position in the midst of key railways, docks and industries. Today it would be called 'collateral damage'. In lower Grangetown bombs hit Bromsgrove Street, Clive Street, Clydach Street, Corporation Road (thirty-two died sheltering in the basement of Hollyman's bakery, the single most fatal event in the entire Cardiff blitz), Ferry Road, Forrest Street, Holmesdale Street, Paget Street, Penhevad Street, Pentrebane Street, South Clive Street and Taff Embankment, while in the tightly packed terraces of upper Grangetown there was carnage in Allerton Street, Compton Street, Court Road, Jubilee Street, Maitland Place, Monmouth Street and Stafford Road. Buildings beyond repair were demolished and their subsequent, post-war replacements make the locations readily detectable today. Clarence Hardware was built on the Hollyman's bakery site in 1958 (known as the 'everything shop' for good reason, it's still going strong); blocks of flats mark bomb zones on the corner of Clive Street and Ferry Road and the corner of Paget Street and Pentrebane Street (the Holmesdale Street/Ferry Road corner where the obliterated 1895 Mansion House stood was left undeveloped); three blocks of maisonettes were built at the devastated northern ends of Allerton Street, Jubilee Street and Stafford Road; and new housing replaced Maitland Place's southern side and its junction with Hereford Street, where the 1901 Saltmead Presbyterian Hall was a notable loss.

In nearby Court Road and Rutland Street a small park and housing estate mark the site of the splendid 1893 Court Road School and its adjacent Infants School – but this particular demolition was not at the hands of the Lutwaffe: the school was repaired post-war before being pulled down by the council in 1970. In fact, under the guise of 'slum clearance', the council has wiped out far more of 'the Grange' than the Nazis ever managed: upper Grangetown's Franklen Street, Lucknow Street, Madras Street and Thomas Street in the 1960s and lower Grangetown's Hewell Street, Knole Street, Oakley Street and Worcester Street in the 1970s.

Roath and Adamstown

War truly came to Roath on 3 September 1940 when bombs rained down on houses in Angus Street, Arabella Street, Claude Place and Moy Road and eleven died. The sites can be spotted today by the different bricks and roofing tiles used in post-war repairs and an entirely new section of terrace in Angus Street. Constellation Street and Moon Street were hit later in the year, killing four, eliminating terraced houses that became the site of Adamsdown primary school and erasing Moon Street from the map.

Then came the bombs of January 1941. Thirteen died in the 'poets corner' area off City Road, where the destruction wreaked on Byron Street, Crofts Street, Lily Street, Milton Street, Rose Street, Shakespeare Street, Talworth Street and Vere Street was so severe that little could be repaired post-war. The entire zone was levelled and replaced by reconfigured roads, the Shelley Gardens estate, new infill housing and commercial premises. Roath got badly bombed again in March when casualties were miraculously few but destruction widespread. The Roath Road

Wesleyan Methodist church, a distinguished presence on the Newport Road/City Road corner since 1871, took such an avalanche of incendiaries it burnt to a shell. The sombre reminder of the war stood for a further fifteen years before being demolished in 1955. Its ground, along with an adjacent row of fine Victorian villas, was taken over in 1969 by the ugly fourteen-storey office block Heron House, once social security offices, these days private equity pawn Eastgate House. John Wesley (1703–1791) would be spinning in his grave. St Martin's in Albany Road was also gutted, but the deeper pockets of the Church in Wales allowed it to be restored by 1955, albeit without its original 1901 polychrome interior, while the marvellous St German's was only just missed by a bomb that wiped out its cute church hall next door on Star Street.

Howard Gardens was changed forever, losing both the 1885 Howard Gardens High School and the 1891 Eglwys Dewi Sant in an oil-bomb inferno. Cardiff's first municipal secondary school was patched up for a while but ultimately the girls relocated to Lady Margaret High on open land off Colchester Avenue in 1948 and the boys joined them at adjacent Howardian High in 1953. Both closed in 1990, the Howardian lives on in the names of a primary school, youth centre, community education centre and nature reserve. Cardiff's Welsh-speaking Anglicans also had to move; in 1956 to the disused 1863 St Andrew's Church in St Andrew's Crescent, rededicated as Eglwys Dewi Sant. The Cardiff College of Art was built on the vacant Howard Gardens plot in 1966, a concrete and brick monstrosity tossed through a series of educational reorganisations before becoming part of Cardiff Met University in 2011 and being relocated to Llandaf in 2014. A 671-bedroom student apartment complex further chanaged this location in 2016, replacing a building that had lasted a mere forty-eight years. Even the Gardens will soon be gone – they've been sold off by the council to the fee-paying Cardiff Sixth Form College.

The Royal Infirmary was peppered with explosives across its large site, resulting in many wards and departments being out of use until the 1950s and the complete destruction of the neighbouring Nurses' Hostel in Newport Road (now an infirmary car park), hospital chapel in Orbit Street (part of the same car park) and Blind Institute on the corner of Longcross Street and Meteor Street corner (a new infirmary block replaced it and Cardiff's oldest charity moved to purpose-built Shand House in 1953 and then Jones Court, Womanby Street, in 2014). Ancient Roath Court was encircled by roof-ripping detonations (post-war replacements can be seen at the Roath Court Road–Albany Road, Richards Terrace–Newport Road and Minster Road–Newport Road junctions) but somehow escaped without a scratch. An unprepossessing 1950s mini-terrace at the bottom of Penylan Road reveals the bullseye of Roath's last serious attack where five people died in 1943.

Outer Suburbs

In the terrible raid of January 1941 an exploding landmine outside Llandaf Cathedral's south aisle claimed the most important architectural casualty of the Cardiff blitz, dislodging the spire, peeling off the roof from end to end, shattering the west window

and the nave and wrecking countless irreplaceable treasures in the interior. The cathedral was reborn in a brilliantly conceived post-war rebuild, welding twentieth-century modernism to the medieval skeleton. Other ecclesiastical properties crushed in the area that night were the 1890 All Saints Church in Gabalfa Road (rebuilt plainly minus its quirky tower in 1955) and the 1907 St Michael's Theological College in Cardiff Road. The college, nowadays not exclusively Anglican but ecumenical, lost two of its four sides – but that turned out to be gain when a stunning chapel by George Pace (1915–1975) filled the gap in 1957. The memory of cowering in his family's Anderson shelter at Fairwater Grove West listening to the shrieking bombs during this raid later inspired Terry Nation (1930–1997) to conceive the megalomaniac, ranting Daleks for the long-running BBC series *Doctor Who*.

Many of the Dornier, Junkers or Heinkel aircraft, lured off target by decoy flares, dropped their cargoes in the surrounding countryside: craters can still be seen in extant fields at Michaelston-super-Ely, Llanedeyrn, Gwynllŵg and on Whitchurch golf course. But bombs did get through to houses in locations as disparate as Bishops Walk, Ely Road, Fairwater Road and Prospect Drive (Llandaf), Pantbach Road and

Memorial at Llandaf Cathedral marking the spot where a parachute mine detonated in 1941. (Peter Broster)

Wenallt Road (Rhiwbina), and Caegwyn Road and Ton-yr-Ywen Avenue (Heath). Because of the two railways running through it, the Heath area was often hit – never more lethally than during the very last raid on Cardiff on 18 May 1943 when most of St Agnes Road, then only ten years old, was eviscerated by a parachute mine and twenty-nine died. As such things fade out of living memory, the sheer arbitrariness of where death came knocking underlines timeless, unpalatable truths: nothing is preordained ... we are all hostages to fortune.

Tsunami

After the 2004 Indian Ocean Tsunami (magnitude 9.2 earthquake, 300,000 dead), a professor at Cardiff University claimed that there had been a similar event in the Severn Estuary 400 years previously, and relabelled the well-documented 'Great Flood of 1607' the 'Cardiff Tsunami'. Eye-catching headlines work wonders for search engine optimisation and raising a university's profile, but they are usually as ephemeral as proverbial chip-wrapper. However, this particular intervention had legs. The BBC followed up with a *Timewatch* documentary fronted by a professor from Bath Spa University (for him, it was the 'Bristol Channel Tsunami'), and then further reiterated the tsunami theory by including the 1607 event in another pop-academic documentary *10 Things You Didn't Know About Tsunamis*. Following the East Japan Tsunami of 2011 (magnitude 9.0 earthquake, 20,000 dead), these devastating giant waves well and truly entered public consciousness and the concept of a tsunami in the Severn gained further traction in books and websites. I don't want to be a spoilsport but in 1607 there was no tsunami, a 'Cardiff' one or any other attention-seeking title for that matter. It was far more frightening than that.

It would take an Atlantic earthquake of at least magnitude 7.0 to generate any sort of tsunami up the Severn. Such a rare earthquake would have been felt across the whole of north-west Europe, and the resulting tsunamis would have hit the coasts of Ireland, Pembrokeshire, Cornwall, Brittany and all points south to Portugal. None of that happened. Not one contemporary source reported earth tremors or unusually large waves. That's because it was something more familiar than an outlandish, once-in-a-millennium tsunami. The flood was caused by a concurrence of quite common phenomena that can only too easily coincide again: an exceptionally high spring tide in the Severn combined with a deep low-pressure Atlantic storm surge.

3,000 people died in the 1607 flood, but few if any perished in Cardiff, then a tumbledown fishing village with a population of less than 2,000. Most casualties were further east, on the Gwent levels, the Somerset levels and upriver as far as Gloucester. Cardiff's moors were swamped as the waters flooded over the ancient sea banks and came as far inland as Canton and Adamsdown, but since they were virtually uninhabited the main victims were sheep. In a town still confined within

The Severn Bore at Minsterworth, Gloucestershire. (Lesmalvern)

its medieval walls the Taff burst its banks and undercut the foundations of the eleventh-century St Mary's Church – but not one death was recorded. So it is anachronistic and ahistorical to make Cardiff the central victim even if it were a 'tsunami'. With the entirely undeveloped intertidal muds, marshes and creeks of the West Moors and East Moors doing their job as a natural blotting paper, and the town in any case sheltered from the onrushing water by the barrier of Penarth Head, Cardiff got off relatively lightly and was mainly damaged by the ebbing backwash.

To Cardiffians this was not a new experience, just a severe version of events that had regularly occurred from time immemorial. There were further major inundations in 1703, 1763, 1764, 1768, 1775, 1792 and 1827 before sea walls were raised in the 1830s to allow dock construction on the East Moors at the start of Cardiff's coal era. Tidal flooding was greatly reduced, but not eliminated. When full-moon spring tides coincided with rain-swollen rivers and westerly gales, Cardiff suffered further soakings, most notably in 1960 and 1979. The coming of the Barrage in 1999 eased the usual tidal worry by dint of severing Cardiff's connection to the sea, but introduced

a new threat by raising the water table and creating a sea-level lake. The body of water routinely rises above the boardwalk in the Inner Harbour when there has been heavy rain in the hills and the Barrage is shut because the tide is high. The complete eradication of the absorbent moors combined with the rising sea-levels and increase in extreme weather events caused by man-made climate change increase the chances of another 1607 happening one day – and next time it won't be the sheep that get it.

The uncomfortable truth is that you would not build a city on a flood plain at the confluence of three turbulent rivers fed by countless mountain streams in one of the wettest parts of Europe and adjacent to a funnel-shaped estuary with the second highest tidal range on the planet, if starting from scratch. The Severn Bore, naturally occurring even in neap tides upstream of Chepstow as the estuary narrows and gets shallower, is real-time evidence of the propensity of the Severn to surge. No, the 1607 flood was not as newsworthy as a tsunami – it was just geography.

U

Ulysses

Apologies to Homer (*c.* 750 BC–*c.* 650 BC) and James Joyce (1882–1941).

Yes Blooms is open again after that fire got a decent bookshop aye O I saw yours there reduced to clear Newport Road is the longest road in Cardiff bet you didn't know that but Cardiff Roads not the longest road in Newport dont know what is mind road to hell most likely no not a mug dont use a mug use a cup and saucer the standard of driving is terrible the speed they go down here should be cameras O but we dont want speedhumps they ruin your suspension Leo's bad coughing like a brokenwinded old horse bowel trouble too on the throne all the time like a thief in the night Mr Davies does the garden lost an eye in the steelworks hot shard done the deed alas they put him on the brush never complains fair dos no compost bins I told him not having maggots dancing a calypso here hes a pro tea up more cake give the kid more cake give her a whole half whoa thats enough to sink a ship how many beans make five my lovely got her fathers nose like you me us cant understand all the fuss about Cilla Black pages and pages of it voice like a wailing siren O fetch the biscuits Mrs Lester comes in once a week and does for me she can get through the biscuits thighs thicker than an ox they call her fat Bet in the buildings fries everything in lard poor dab I suppose youve heard Helen kicked him out what it is found messages on his phone seeing other women he was the bloody fool never knew how to conduct himself familys the most important thing she made a lovely nest the lotuseater threw it all away end up in Whitchurch he will you watch sarcasm is the lowest form of wit hardly ever go into town anymore dont like it nowhere to spend a penny long journey home I get the park and ride Eastern Avenue O the Rogers have built an extension breakfast room she calls it breakfast room I ask you worked in Morgans The Hayes for so long the pottery on Rumney common did her a plate he sold cars Penarth Road do anything for a quick buck Ill put the kettle on now in a minute nothing on telly Match of the Day is awful who is that nauseating man Swansea won O nothing will mollify. I was a spirit of the forests yes when I cycled through the lanes up to the bluebell woods yes and how he hoisted me over Ruperra wall and I thought well as well him as another and then

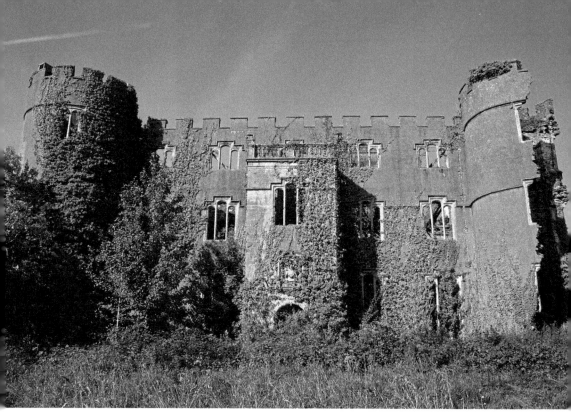

Ruperra Castle. (Andrew King/Flickr)

I led him with stealth to the Castle yes and then he asked me if I ever yes to say yes my black brook tadpole and first we climbed the tower yes and then we ran down to the river so we could feel the cold water all muddy yes and his eyes were shining like stars and yes I said yes I am Yes.

V

Victoria Park Lake

This showpiece municipal park was unveiled in 1897 complete with a kidney-shaped ornamental lake created from the waters of the Nant Sisli, a brook that ran down from Ely Rise before dissolving into myriad creeks on the West Moors. Big enough to accommodate the overweight Atlantic grey seal Billy from 1912 to 1939, today the much reduced lake is a shallow paddling pool, heaving with small children in the summer holidays.

Wenallt

Winter is the best time to see Cardiff from its northern range of hills, particularly at the Wenallt, where the thick deciduous woodland is bare of the foliage that blocks views in summer. At the top of Heol-y-Wenallt there is a car park opposite giant radio transmitters. From here one can meander off into publicly owned Coed-y-Wenallt, 44 hectares (110 acres) of remnant ancient woodland brimming with birdlife, and work a zigzag route towards the Wenallt's brow.

Then, quite suddenly, Cardiff appears, shimmering in the watery light through stands of birch and beech. 750 feet (230 metres) below the red sandstone ridge, spreadeagled across its wide delta, it has a surprising unfamiliarity. Can that gleaming, futuristic city by a glassy sea be my dirty old town? Can those steepling towers and straining turrets really be my down-at-heel warren of grey terraces? Distance indeed lends enchantment to the view.

At the southern foot of the sandstone hill that watches over Cardiff is Wenallt Reservoir, a discus-shaped storage reservoir holding 15 million gallons and covered by a corrugated roof, built in 1924.

Wentloog Corporate Park

Since the 1960s Cardiff has relentlessly encroached onto the delicate watery world of Gwynllŵg, the Wentloog Levels, supposedly a protected SSSI. Among the multitude of 'business parks' is Wentloog Corporate Park, where a number of little ponds have been scattered among the sheds. Nearby, on the ravaged coast at Newton where the earth has been gouged away by soil supply, 'recycling' and waste management operators, there are another four ponds. Despite their surroundings, these ponds are the closest in this list to being 'natural' – simply because any impression in the great Gwynllŵg sponge immediately fills with water.

X

X-Certificate

Not for the squeamish, a few of the many murdered in Cardiff:

Arthur Allen (1902–1940)
In his Kent Street lodgings in Grangetown, George Roberts broke his friend's skull with an iron bar before dumping Allen's still-alive body in nearby Bradford Street, all for the sake of a few quid. Arthur, home on leave from the navy, took two months to die in Cardiff Royal Infirmary. The charge of wounding was upgraded to a charge of wilful murder and twenty-nine-year-old Roberts was promptly executed.

Doris Appleton (1903–1921)
Lester Hamilton, a Jamaican marine fireman, shot his ex-girlfriend Doris in the face when she answered the door of her house in Cwmdare Street, Cathays. He then went back out into the street and shot himself in the head. She died, but he didn't. Paralysed down his left side, he had to be carried to the noose.

Julian Biros (1891–1913)
Spanish seaman Biros, one of thousands of casual labourers of no fixed abode looking for work in Cardiff docks, had a dagger plunged into his heart alongside Roath Dock by another labourer, Hugh McLaren. The men knew each other: they were among many who slept rough in the Crown Patent Fuel Works nearby and used an abandoned railway carriage as a kitchen (an area now occupied by the BBC's Roath Lock studios). The argument had been about a packet of tea. Unrepentant McLaren was hanged in Cardiff jail's execution chamber five months later.

Henry Blatchford (1836–1900)
The retired Canton widower was blown away by a shotgun at point blank range by sixteen-year-old Tommy Sweetman in the backyard dairy at the Sweetman's home in Conybeare Road, where Henry did odd jobs for Sweetman's father. Bipolar and epileptic, Tommy had previously been released from a mental asylum against the advice of his doctor – the mistake wasn't made again.

Jean Challenger (1924–1956)
Newlywed Jean from Roath had cycled out to then rural Llanedeyrn and was blackberrying among the fruit-laden hedgerows of Peggy Giles Field on Llwyn-y-Grant farm (near today's Park Inn on Circle Way East) when she was bludgeoned to death by an onslaught of powerful blows to the head. She was so disfigured her husband could only identify her body by the clothes. The finest brains in Cardiff City Police (founded in 1836, absorbed into South Wales Constabulary in 1969) never found the culprit.

Joyce Cox (1934–1939)
Nobody was ever caught for the sexual assault and murder of four-year-old Joyce, found by the Cardiff Railway cutting near Coryton station. More than seventy-five years later, the police still refuse to release their files on the case because to do so would be 'unfair' to a mystery suspect. One can only presume he's a VIP.

Honora Dutch (c. 1815–1865)
Alcoholic Honora was kicked to death by her abusive husband John Dutch in the backyard of their tenement (demolished 1902) on Gray Lane, Canton. Neighbours who had come out to investigate the commotion stood and watched. Endorsing the then routine idea that a husband could do what he liked to his wife, the court was lenient. It was judged to be manslaughter and John Dutch got ten years hard labour.

Philip Evans (1645–1679) and John Lloyd (c. 1640–1679)
Before most public executions were moved to the exterior of Cardiff's first purpose-built prison in St Mary Street in 1700, they used to take place at grim Cae Budr and Plwcca Halog fields on the outskirts of the town (today's equally grim, City Road and Albany Road junction between Richmond Road, Crwys Road, and Mackintosh Place). Here was the scene of numberless barbaric lynchings – none more infamous than when these two Catholic priests were hanged, drawn and quartered at the height of Catholic persecution in the reign of Charles II (1630–1685). Their skeletons and entrails were left to decompose on the gibbet for years – *pour encourager les autres*. They were canonised as martyrs by Pope Paul VI (1897–1978) in 1970.

Winifred Fortt (1897–1917)
Greek sailor Alex Bakerlis swung from the Cardiff scaffold in 1918 for his frenzied knifing of one of the daughters of the owner of the house in Bute Street where he lodged between ocean voyages. Impossibly jealous and possessive, twenty-five-year-old Bakerlis killed Winifred on the Bute Street bridge over the Junction Canal (filled in 1964).

Stephen Gilbert (1894–1936)
Mutilated beyond all recognition in the stockroom of his greengrocer's shop on the corner of Croft Street and Clive Place corner in Roath, Gilbert bled so extensively that

it seeped through the floorboards and formed a pond in the cellar below. Investigations focused on his gambling and sexual predilections but drew a complete blank.

Carrie Gilmour (c. 1875–1907)
Big-hearted Carrie Evans from Llanelli married badly, escaped to Mary Ann Street in Cardiff and slid into alcoholism and prostitution. A policeman on early morning patrol came across her lying in a pool of blood on West Canal Wharf, her face slashed and her windpipe severed, surrounded by her empty purse and a few pathetic halfpennies. Local residents had heard her screams in the night but went back to sleep. Psychopathic sailor Patrick Macdonald confessed the next day, was sentenced to life imprisonment and died behind bars in 1934.

Gladys Ibrhim (1897–1919) and Aysha Ibrahim (1919–1919)
Twenty-three-year-old steamship fireman Thomas Caler from Zanzibar slit the throats of Gladys and her eight-month-old baby daughter with a razor at Gladys's Arab refreshment house in Tiger Bay's Christina Street (demolished 1968). Post-mortem, he raped Caerffili-born Gladys and stole a gramophone and cash. Despite being caught red-handed with a blood-soaked razor and the gramophone, Caler protested his innocence all the way to his appointment with the hangman.

Susan Ingram (1831–1874)
James Gibbs, Susan's vain, womanising husband was the butler at Llanrumney Hall, then the country estate of the Williams dynasty. He had abandoned her repeatedly in England, but the deluded woman kept coming back for more, making the fatal mistake of following him to Llanrumney. He beat her to pulp, cut her throat so deeply he almost severed her head and then left her body in a ditch by Ball Farm (located where Weston Road and Worle Avenue would be built in the 1950s). Sobbing in his hood, Gibbs was hanged at Usk jail.

Dai Lewis (c. 1890–1927)
Ex-boxer, heavy drinker and small-time thug Dai paid the ultimate price for trying to muscle in on the lucrative protection racket the Rowlands gang operated at Ely racecourse. He was knifed to death outside the Blue Anchor in St Mary Street (now Sports Bunker). John Rowlands admitted manslaughter in self-defence (it was Lewis's knife) but he, his brother Edward and Danny Driscoll were all found guilty of murder and sentenced to death. Then John went berserk in custody and was sent to Broadmoor for life and the two who didn't do it were both hanged in 1928.

Thomas Lewis (1818–1848)
The knifing to death of Thomas Lewis of David Street by Irishman John Connors outside the newly built St David's Catholic Church at the corner of Stanley Street and Whitmore Lane (Bute Terrace) unleashed a week of appalling violence in 1848,

Cardiff's first race riot. Ten thousand wretchedly poor Irish immigrants had recently been shipped to Cardiff by the Butes at the height of the Great Famine. They were paid a pittance building docks and railways on the cheap, thereby undercutting wages, depriving locals of employment and virtually overnight altering the entire culture, language and demography of the town. The exploited Irish were forced to live in indescribably overcrowded and filthy conditions and ravaged by cholera outbreaks – still a step up from starving in Connemara – and their exploitation was at the expense of the Welsh, driven to the workhouse or effectively turfed out of their home town. This was an old ploy: set Celt against Celt, worker against worker, divide and rule and unfortunately it worked; Cardiff has not had a Welsh-speaking majority, a pro-Wales majority, a radical majority or a high-wage economy ever since. Connors was found guilty of manslaughter rather than murder, but suffered a fate worse than death: he was transported to the hell on earth of the Botany Bay penal colony and died in Australia. The Motorpoint Arena now covers the site of David Street, Stanley Street and the church.

Maud Mulholland (1894–1913)

After shop assistant Maud of Theobald Road in Canton ended her relationship with the boy next door – needy, controlling, insurance agent Edward Bindon – he bought a revolver and shot her six times at point-blank range in Denton Road one Sunday evening. Bindon gave himself in and at first acted cocky and satisfied. But the twenty-year-old wasn't so sanguine four months later when he was dragged weeping and whimpering to the prison gallows.

Dic Penderyn, aka Richard lewis (1808–1831)

The 1831 Merthyr Rising, in which at least twenty-four unarmed men, women and children were shot dead by British troops on the streets of the iron town during protests against wage cuts, oppression, evictions and starvation, was a pivotal moment in Welsh history. The rebels inflicted unprecedented defeats on the military over a week of heroic resistance, for the first time ever the red flag was raised as a symbol of revolt, and the events were central to the emergence of the Welsh working class. After the sheer might and shoot-on-sight policy of the British forces prevailed, the Whig government in London decreed that someone, anyone, should be hanged as an example. Almost at random young Dic Penderyn was hauled out of the crowds and chosen by the authorities. On trumped-up charges of wounding a soldier he was summarily tried, convicted and then publicly hanged outside the gaol in St Mary Street (today the site of the Central Market). Cardiff was chosen as the location for this state-sanctioned assassination because the compliant, conservative population could be relied on not to protest. In 1874 Welsh American Ieuan Parker, on his deathbed in Pennsylvania, confessed to a priest that it was he who had injured the soldier. Dic's last words, 'O Arglwydd, dyma gamwedd' (O Lord, what an injustice), would make a fitting motto for the city.

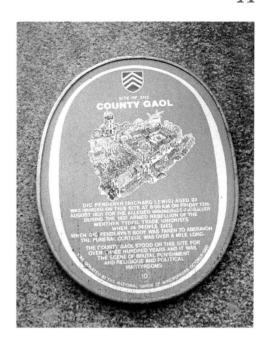

Plaque commemorating Dic Penderyn outside Cardiff Market, St Mary Street.

William Perry (1836–1873)

Deranged Wharton Street pork butcher John Jones (real name Benjamin Swann from Wolverhampton) committed the ultimate crime in the Westgate Hotel: he killed a police officer. In the pub's entrance lobby he plunged a fearsome cleaver deep into old acquaintance PC Perry of Heath Street in Riverside, and then did the same to himself. Perry died instantly on the Cowbridge Road pavement; Jones six days later in the infirmary, tearing open his wounds and howling in agony.

Harriet Stacey (1855–1904)

Unstable, diseased Harriet from Hereford was found strangled and tied to her bed with a washing line in Saltmead (now Stafford) Road, Grangetown. Detectives were stymied by her secretive and complicated private life; whoever killed her got away with it.

David Thomas (c. 1840–1885)

If a spur-of-the-moment murder is bad, how much worse is capital punishment; a calculated, cold-blooded, merciless murder by the state? A classic example of its insane inhumanity is the 1886 execution of David Roberts in Cardiff jail for the ferocious murder of Cowbridge farmer David Thomas. Because the hangman miscalculated Roberts' weight and the drop ratio, the condemned man wriggled, twitched and heaved for breath for a full ten minutes before he died, to the mounting consternation of those present. As a result, the Home Office issued new, mathematically precise hanging guidelines. Capital punishment for murder was abolished eventually in the UK in 1965 but it wasn't until 1998 that the death penalty was abolished altogether.

Lynette White (1967–1988)

The savage murder of sex worker Lynette in a squalid room in James Street, Butetown, is notorious in the annals of crime. It featured the longest murder trial in British history up to that point (at Swansea Crown Court) and a famously grotesque miscarriage of justice that saw three mixed-race men spend three years in prison for a crime they didn't commit before their convictions were overturned on appeal. The campaign to free the 'Cardiff Three' (Yusef Abdullahi, Stephen Miller and Tony Paris) was one of the most high-profile of its kind, with TV documentaries on Channel 4 and the BBC, and marked a turning point in the fight to hold the police to account. South Wales Police at first refused to reopen the case, implying the men were still guilty, but in 2002 had to admit they were wrong when new DNA technology led to the real killer, reclusive security guard Jeffrey Gafoor. The Cardiffian was sentenced to life imprisonment in 2003, receiving a shorter minimum tariff than had been given to the wrongfully convicted men, but the case was far from over. An interminable review by the Independent Police Complaints Commission eventually resulted in the jailing of three of the original prosecution witnesses for perjury, the arrest of thirteen former and serving police officers and the largest police corruption trial in British criminal history – but that collapsed in 2011 because the defence claimed key files had been destroyed (they had not; the files were found the following year). This outcome was labelled 'the biggest scandal in the history of British justice' by respected investigative reporter Tom Mangold, who had covered the case for Panorama, and 'a very sad day for justice' by journalist Satish Sekar, who wrote the definitive account

No. 7 James Street, where Lynette White was murdered. (Foomandoonian)

of the shameful deeds, *Fitted In: The Cardiff 3 and the Lynette White Inquiry*. To compound the injustice, all the officers involved were allowed to retire and then eight of them sued South Wales Police for damage to their reputations! These civil actions are delaying a new inquiry, announced by Home Secretary Theresa May in 2015, into 'the unresolved questions surrounding the reasons why no one was found responsible for this appalling miscarriage of justice'. Desperate, pimped, trapped, and mutilated Lynette has not fallen silent yet.

Thomas Williams (1850–1869)

After a night on the tiles nineteen-year-old apprentice ships pilot Thomas was knifed outside the Rothesay Castle pub in Bute Street (demolished 1971, now the site of a vacant office next to the PDSA). The blade completely opened up his abdomen. Gallono and Pietro Gastro, Italian brothers on shore leave, were executed for this trademark Tiger Bay murder – one among countless in the nineteenth century to involve sailors, alcohol, knives and convenient 'foreign' scapegoats.

Rhoda Willis (1863–1907)

Sunderland-born Rhoda (aka Leslie James) was hanged at Cardiff jail on her forty-fourth birthday for 'baby farming', the lurid phrase that referred to the widespread practice, before adoption and fostering laws were introduced, of being paid to take in unwanted babies – usually those of rich women seeking to avoid the scandal of an 'illegitimate' baby in a censorious, moralistic era. Poor Willis, who rented rooms in Splott's Portmanmoor Road, was executed, the last woman to be hanged in the UK for the offence and also the last woman ever hanged in Cardiff.

Ysgolion (Welsh Schools)

The Welsh language wasn't officially recognised by the UK government until the 1967 Welsh Language Act, primary schools weren't obliged to include Welsh on the curriculum until 1990, and equal status with English didn't arrive until the 1998 Government of Wales Act that set up the National Assembly. All of these tiny, hard-won advances are applicable only in the public sector and only in Wales, meaning the native British tongue still has no legal recognition in the rest of 'Britain'. In 1999 the Assembly introduced the right of every child in Wales to be taught Welsh in school up to age sixteen, a measure that was desperately needed to staunch the catastrophic

The Wales Millennium Centre offices of Urdd Gobaith Cymru, founded by Welsh education pioneer Ifan ab Owen Edwards in 1922. (Seth Whales)

decline of a language spoken by 95 per cent of the population just 150 years ago but a mere 20 per cent today.

If the 'language of heaven' is to be saved, first-language immersion rather than tokenistic second-language dabbling will be required on a large scale. Painfully slowly, Welsh-medium education has been introduced around Wales, usually thanks to groundswell pressure from below in the face of inaction from above.

The first Welsh-medium primary school was Ysgol Gymraeg in Aberystwyth. Launched as a private school in 1939 by the founder of the Urdd youth movement, Ifan ab Owen Edwards (1895–1970), it became a state school in 1952. The first Welsh-medium secondary school was Ysgol Glan Clwyd, opened in Rhyl in 1956 (relocated to St Asaph in 1969). Cardiff, despite being the capital, has been a follower not a leader; successive councils dragging their feet and only introducing Welsh schools grudgingly when forced to by sheer demand from parents. The first Welsh primary school was Ysgol Bryntaf (now Ysgol Pencae) in Llandaf in 1955 and the first Welsh secondary was nearby Ysgol Glantaf in 1978. There is still a massive under-provision in Cardiff: a mere 8,000 (15 per cent) get a Welsh-medium education out of 52,000 school-age pupils. Meanwhile, there is an ever-growing, unmet demand for an education in Welsh sitting alongside 6,000 surplus places in the English-medium schools. Currently, Cardiff has sixteen English-medium secondary schools and eighty-two (plus two bilingual) English-medium primary schools.

Zombie Nation

Kernkraft 400 was a big hit in 1999 for Zombie Nation, a techno/electro project of German DJ/producer Florian Senfter, who had remixed it from the soundtrack of a 1984 computer game. Soon being chanted in sports stadia around the world, it was adopted by Welsh football fans during the triumphant qualification campaign for Euro 2016 and, somehow, the galumphing rave anthem has become a Welsh totem.

Gareth Bale. (Jon Candy/Flickr)